IMAGES
of America

MT. BALDY

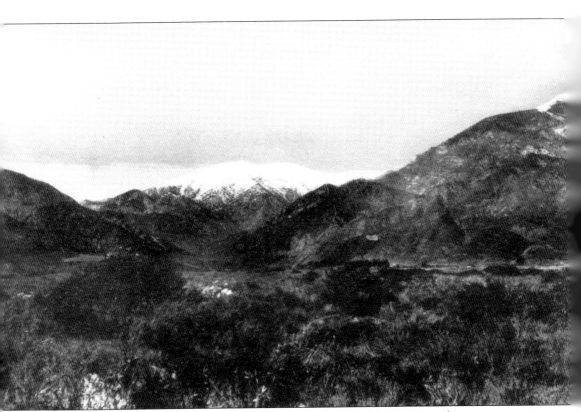

This postcard image, captured during the early years of Camp Baldy, brings together two contrasting scenes, the chaparral of San Antonio Canyon and the snow-covered, 10,064-foot peak of Mount San Antonio, most commonly known these days as Mt. Baldy. (Courtesy of the author's collection.)

ON THE COVER: Visitors saddled up on mules stop for a photograph outside of the Camp Baldy office in 1925. The terrain of the canyons did not intimidate hardy women such as those seen here dressed in traditional attire of the day and ready to ride on the trails in standard saddles. (Courtesy of the Security Pacific Collection, Los Angeles Public Library.)

IMAGES
of America

MT. BALDY

Kimberly J. Creighton

ARCADIA
PUBLISHING

Published by Arcadia Publishing
Charleston SC, Chicago IL, Portsmouth NH, San Francisco CA

Printed in the United States of America

Library of Congress Catalog Card Number: 2008933035

For all general information contact Arcadia Publishing at:
Telephone 843-853-2070
Fax 843-853-0044
E-mail sales@arcadiapublishing.com
For customer service and orders:
Toll-Free 1-888-313-2665

Visit us on the Internet at www.arcadiapublishing.com

For all of the residents and fans of Mt. Baldy

CONTENTS

ACKNOWLEDGMENTS

I offer the utmost gratitude to the full-time and occasional residents of Mt. Baldy who generously contributed the photographs and/or information found in this book: Jane Leffler; Dee Hanson; Daven and Brenda Gray; Liz Dills; Joel, Jean, and Paul Gillingwators; Ray and Dwight Minnich; Ellen Chase; Joel Harper; Brad Hardesty; John Jandrell; Sandy Rady; Pat and Evan Chapman; the Bescoby family; members of the Angeles Chapter of the Sierra Club; staff of the Mount Baldy Zen Center; fire chief Bill Stead; and finally, Pavel, Tom, and all of the other regulars and staff of the Mt. Baldy Lodge.

Thank you to all of the exceptional librarians and archivists who enthusiastically assisted me with photographs and archival materials: Carolyn Cole, Matthew Mattson, and Bettie Webb of Los Angeles Public Library; Carrie Marsh and Jennifer Bidwell of Honnold/Mudd Library of the Claremont Colleges; Gina Sizoo of Upland Public Library; Bruce Guter and Alan Lagumbay of Pomona Public Library; Debbie Henderson of Sierra Madre Public Library; Kelly Zackmann of Ontario City Library; Michele Nielsen of the San Bernardino County Museum; and Marilyn Anderson and the volunteers at the Cooper Regional History Museum in Upland.

I extend my sincere appreciation to the legendary John Robinson, who offered his guidance and shared his depth of knowledge.

Gratitude goes out to Erik von Wodtke and Patrick Keegan, without whom I would not have had this opportunity.

Heartfelt thanks are extended to friends, family, and colleagues who offered support and pep talks throughout the compiling of this book: Darlene Eliot, Tony Viviano, John McKnight, Jim Rizor, Maria Novoa, Letitia Creighton, Michael Creighton, Dwayne Johnson-Cochran, Judith Strawser, Christina Rice, Colleen and Ken Caddell, Patrick Keegan, Ani Boyadjian, and Anne Olivier. My interest in "yesteryear" would not have developed without Howard Drucker, whose extensive knowledge and love of history expanded my mind long ago. Thank you, John Harrelson, for getting me started on my professional journey; I would not have reached this point without your support and encouragement.

A final thank-you goes to Arcadia editor Jerry Roberts, who patiently guided me through the creation of this book.

INTRODUCTION

The grandeur of the San Gabriel Mountains makes the range one of the most popular in Southern California. Its tallest peak, Mount San Antonio, most commonly known as Mt. Baldy, is seated atop San Antonio Canyon, a large alluvial fan. Not unlike other canyon and mountain communities of Southern California, Mt. Baldy has had a vibrant history just in the few decades that Anglo settlers and residents have recorded it. Sadly, little is known of how the native Tongva peoples experienced life in the canyon.

Fortune hunters seeking gold, gems, and minerals arrived in San Antonio Canyon in droves from the mid-1850s until the early 1900s. The search for gold was common among new California arrivals during the Gold Rush, but after decades of minimal success in San Antonio Canyon, such pursuits were abandoned. In the 1880s and 1890s, the clean and abundant water from San Antonio Creek enticed businessmen and real estate developers, who saw the resource as a means to guarantee the success of their business interests in the nearby arid communities of the Ontario Colony and Pomona.

The outdoor enthusiasts during the earliest years of the great hiking era traveled in large numbers up the canyon to enjoy the beautiful surroundings, seek relief from the warmer temperatures found in the valley below, and to camp, hunt, and fish. Later on in the early 1900s, as outdoor recreation gained popularity, the canyon earned the reputation as one of the most desirable summertime resort destinations in the region. Cabins and camps appeared high and low throughout the canyon and helped usher in an era of tourism not seen before in this area of the San Gabriel Mountains. From 1909 until the late 1930s, Camp Baldy, the center of the canyon's resort activity, thrived as a destination for anyone in search of adventure and natural beauty. It was easily accessible from most Southern California towns and cities. The popularity of the camp was not limited to a particular demographic; families, college students, Hollywood celebrities, and religious groups of all faiths all came to experience Camp Baldy.

The heyday of Camp Baldy came to an abrupt end in 1938 when abnormally heavy springtime rains produced floods, wreaking havoc in canyon and rivers areas throughout Southern California. The intensity of the floodwaters in San Antonio Canyon destroyed a significant amount of what had been a beloved resort and home to many. Numerous cabins, homes, businesses, and lodge and resort facilities were crushed by torrents of water and boulders. Canyon life after the flood was never the same.

In 1952, the residents of Camp Baldy petitioned to change the name of their community from Camp Baldy to Mt. Baldy, not Mount Baldy, as commonly believed. The name change signified a new era for the once seasonal resort that was well on its way to becoming a year-round residential community. Throughout the 1950s, with the help of dedicated locals such as the Leffler, Chaffee, Pruitt, Chapman and Wisely families, the young unincorporated town of Mt. Baldy came into its own and witnessed the development of a new mountain road designed to withstand seasonal flooding, a dam at the mouth of the canyon for flood control, and state-of-the-art ski facilities located at the top of the canyon. Near the center of the former Camp Baldy, the residential community of

Mt. Baldy Village constructed a church, a post office, and a volunteer fire department. Another era of successful tourism and swelling popularity followed.

During the decades when camps and resorts arose throughout the larger San Antonio Canyon, resorts and privately owned cabins in the tributary canyons of Bear, Barrett, and Stoddard were also developed and exist to this day. Specific areas of San Antonio Canyon such as Manker Flats serve as unique neighborhoods as well, but even though each specific areas and canyon has a distinct character, each is considered a part of the greater Mt. Baldy community.

The visual journey presented here traces the eventful history of Mt. Baldy as it transitioned from being a seasonal resort to a place that a small community calls home.

One

TAPPING INTO
RESOURCES

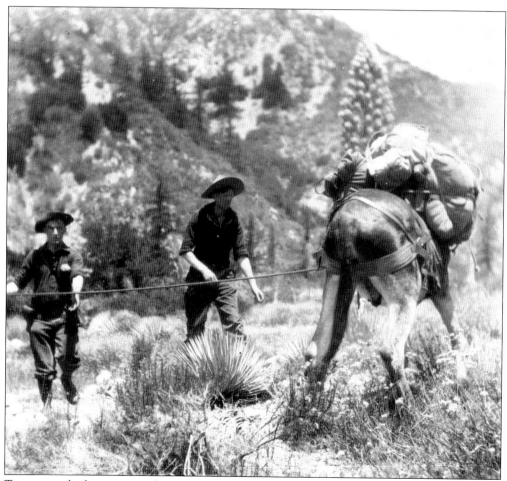

Two men embark on a trip up San Antonio Canyon with a pack mule carrying a variety of necessary provisions. Mules and burros enabled early hunters, miners, and hikers to access hard-to-reach areas for short- and long-term stays. (Courtesy of the Cooper Regional History Museum.)

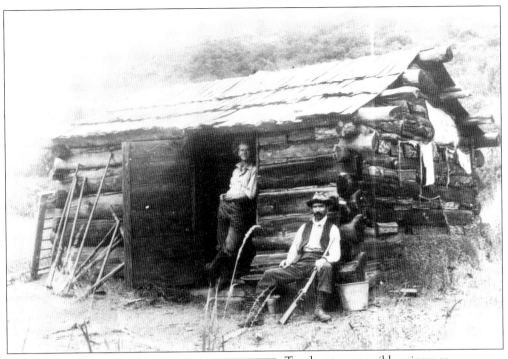

Two hunters, possibly miners as well, are pictured at their modest cabin, located in an unidentified area of San Antonio Canyon. The view captures the adventure and challenges experienced by the earliest explorers and recreation seekers in the canyon. (Courtesy of Daven Gray.)

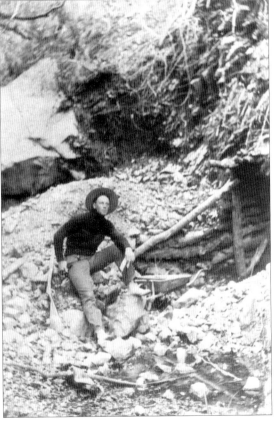

A miner sits outside of an adit, or mining entrance, in an unidentified area of San Antonio Canyon. (Courtesy of Daven Gray.)

The grave of Jacob Shinner, a miner who met his death after he was covered by a landslide, was originally located at the Hog's Back. The grave was later relocated during the construction of Mt. Baldy Road, which was completed in 1955. (Courtesy of the Cooper Regional History Museum.)

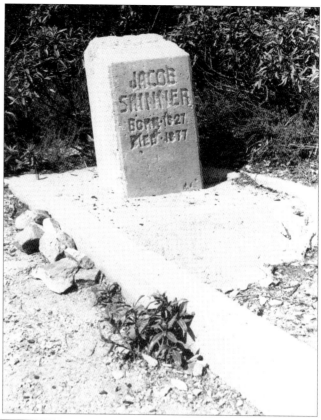

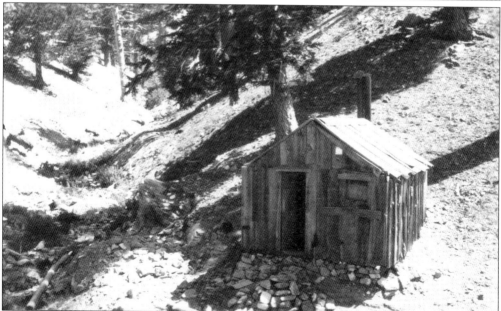

A small cabin sits on the hillside at Miners' Camp, founded by James Banks in the 1880s. Located up at the Notch, in the upper canyon where the ski lifts are now located, the camp was active for approximately 50 years. (Courtesy of John Robinson.)

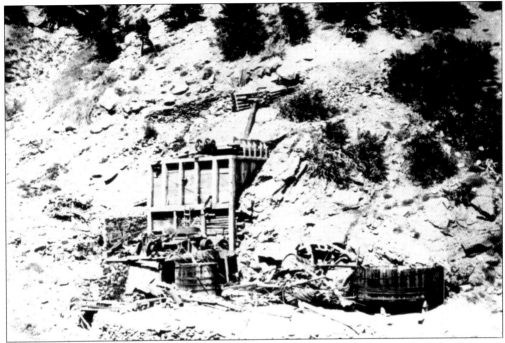

Gold Ridge Mine, at the top of San Antonio Canyon, was where the desire to find the "big one" was shared by many a miner. (Courtesy of John Robinson.)

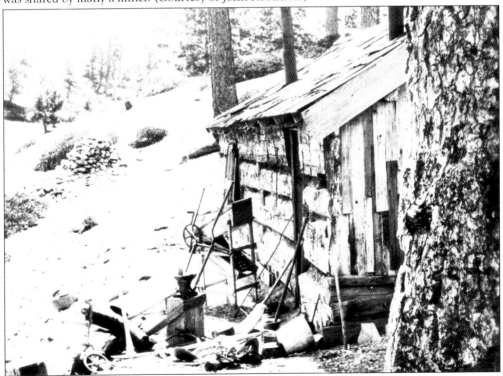

This is another cabin located at the popular Miners' Camp. The scattered mining debris tells a great deal about the fortune seeking that took place here for decades. (Courtesy of John Robinson.)

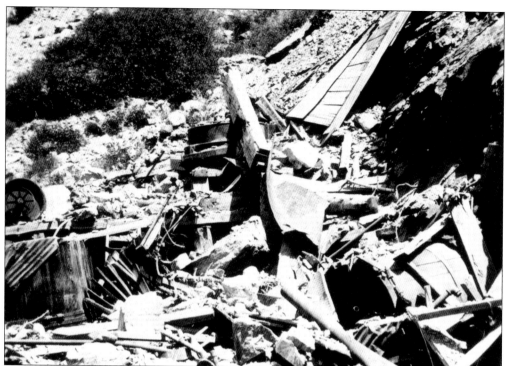

Abandoned mines were a common sight in San Antonio Canyon in the early 20th century. Once miners realized fortunes could not be had in the canyon, investors and businessmen moved on to other interests. (Courtesy of John Robinson.)

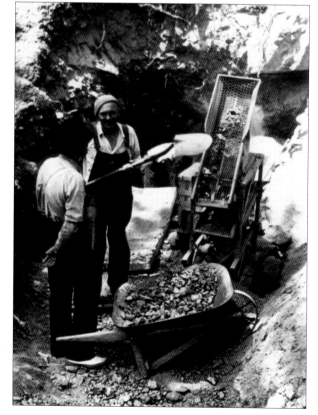

Even in the mid-1930s, the search for local gold, minerals, and gems continued. Earlier methods involved hydraulic mining, but these men are shown engaged in a dry-mining operation. (Courtesy of John Robinson and Dee Trent.)

This view down the canyon offers a glimpse of the power plant (lower left) owned by the Pomona Water and Power Company, a short-lived venture. (Courtesy of the Cooper Regional History Museum.

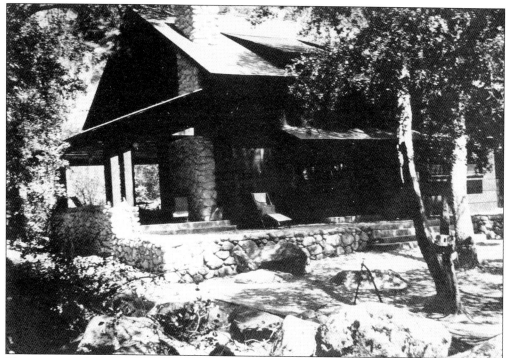

This is a partial view of the mountain retreat belonging to early electric-power icon George W. Kerckhoff. The retreat is located on privately owned acreage known as the Kerckhoff Ranch. The entrance to the home is on the far right, and the stream is just out of view on the left. Built in 1917, the home continues to stand today. (Courtesy of the Wheeler Scrapbooks, Special Collections, Honnold/Mudd Library of the Claremont Colleges.)

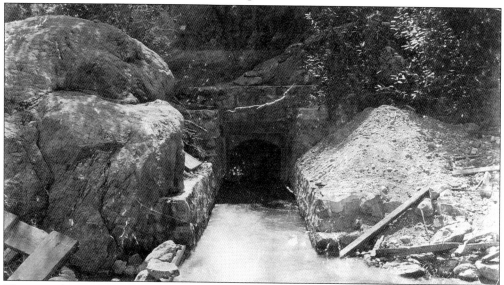

This tunnel was cut through the Hog's Back, an ancient landslide that made access to the upper canyon difficult until a road was carved in 1912. The manpower required for this boring was not without casualties. (Courtesy of the Wheeler Scrapbooks, Special Collections, Honnold/Mudd Library of the Claremont Colleges.)

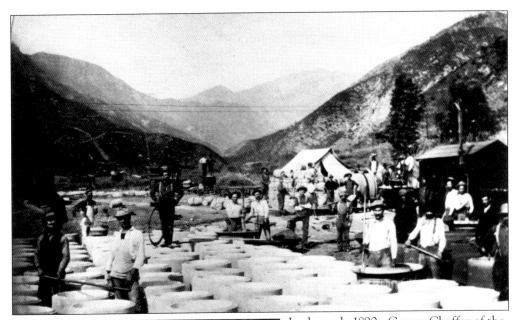

In the early 1890s, George Chaffey of the Ontario Colony pushed to access more water by tapping into the subterranean sources in San Antonio Canyon. Chaffey first began a method by which he collected water in 1883. Laborers of various nationalities laid approximately 3,000 feet of clay water pipe to convey water from San Antonio Canyon to the colony below. (Courtesy of the Cooper Regional History Museum.)

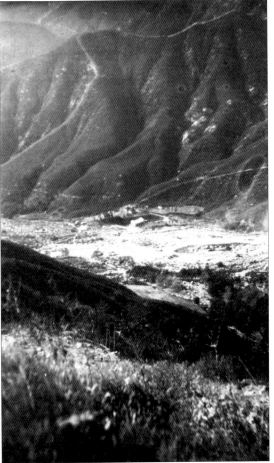

This early view looks down the canyon upon one of the two power stations and neighboring cabins. The powerhouse stands to this day. (Courtesy of the Cooper Regional History Museum.)

The San Antonio Power House No. 1, owned and operated by the San Antonio Light and Power Company, is located in lower San Antonio Canyon. The Edison Company continues to operate this powerhouse. (Courtesy of the Robert E. Ellingwood Model Colony History Room, Ontario City Library.)

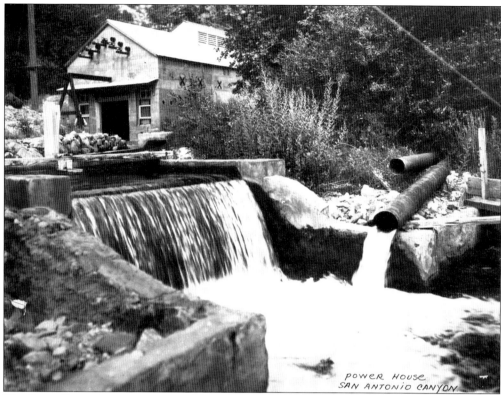

The Sierra Power Station was named for the Pomona-based Sierra Power Company, who owned the facility. The interior view (below) includes the powering dynamos. The powerhouse's close proximity to San Antonio Creek placed it in the path of destruction when the massive flood of 1938 struck. (Both, courtesy of the Wheeler Scrapbooks, Special Collections, Honnold/Mudd Library of the Claremont Colleges.)

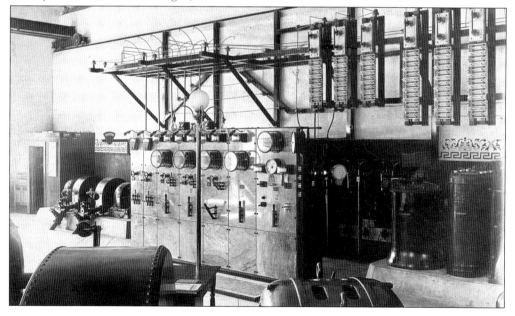

Two

EARLY CAMPS
AND RESORTS

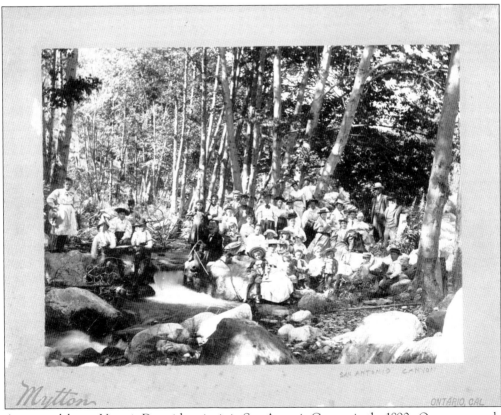

A group celebrates Victoria Day with a picnic in San Antonio Canyon in the 1890s. Once commonly observed in the United States by immigrants from the United Kingdom and Commonwealth countries, the holiday, celebrated on May 24, honors the birth of Queen Victoria (1837–1901). (Courtesy of the Robert E. Ellingwood Model Colony History Room, Ontario City Library.)

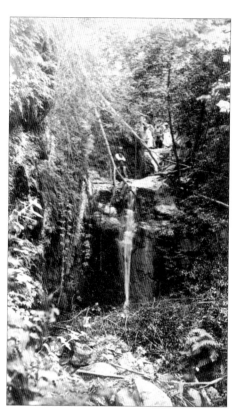

Visitors stand on ladders in the midst of Fern Gorge, which was sometimes mentioned as Fern Canyon in early travel documents. Fern Gorge was one of the most popular destinations for visitors from the 1880s through the 1920s. (Courtesy of the Upland Public Library Local History Collection.)

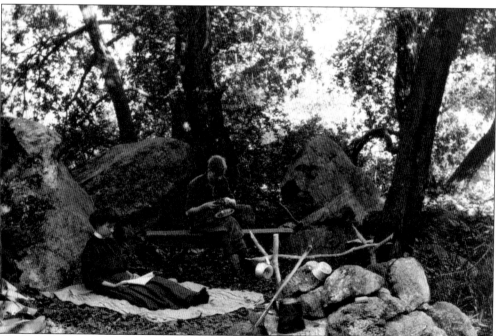

In the earliest days of recreational activity in the canyon, hikers and campers were found to be satisfied with the simplest of provisions. Here a couple, George and Minnie Schneider, is seen relaxing at their day camp in San Antonio Canyon. (Courtesy of the Cooper Regional History Museum.)

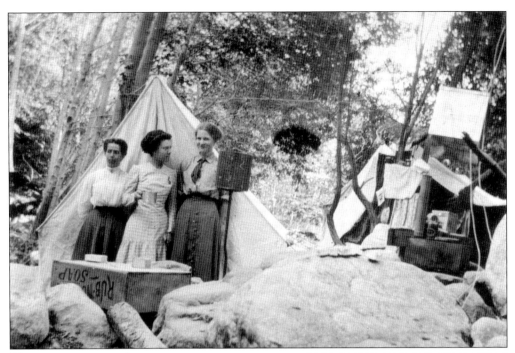

Three young women share a camp, which appears to be well stocked with enough supplies for a long summer stay. The expressions of their faces indicate that much fun was had. (Courtesy of the Upland Public Library Local History Collection.)

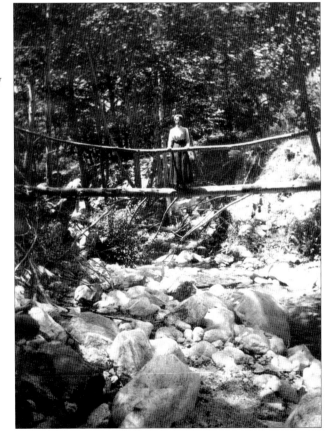

A woman steps to pose for a photograph on a wooden footbridge placed over a dry San Antonio Creek. (Courtesy of the Cooper Regional History Museum.)

William Stoddard, brother-in-law of Collis P. Huntington of railroad fame, came west to seek his fortune in gold mining in Northern California. Stoddard arrived in San Antonio Canyon in 1880, six years before he started Stoddard's Camp, located in Stoddard Canyon, a tributary canyon of San Antonio Canyon. The camp included a shady grove, access to the nearby waterfall (Stoddard Falls), dining facilities, and cabins. (Courtesy of John Robinson.)

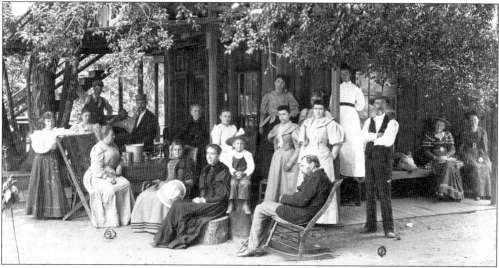

Visitors are seen at Stoddard's Camp. Stoddard (standing on the far right) entertains his guests with the help of his housekeeper, Lizzie, who is seated in the wicker chair on the left. (Courtesy of the Wheeler Scrapbooks, Special Collections, Honnold/Mudd Library of the Claremont Colleges.)

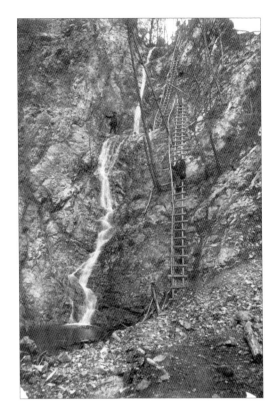

Stoddard Falls attracted numerous visitors from local foothill communities. Ladders provided access to the upper falls, but the terrain was steep, so for those weary of the height, enjoyment could be had at the base of the falls. (Both, courtesy of the Cooper Regional History Museum.)

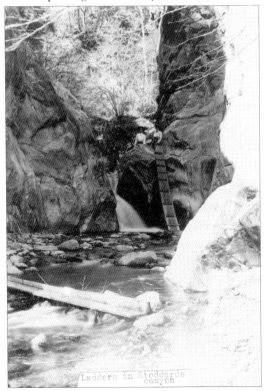

Ladders in Stoddards canyon

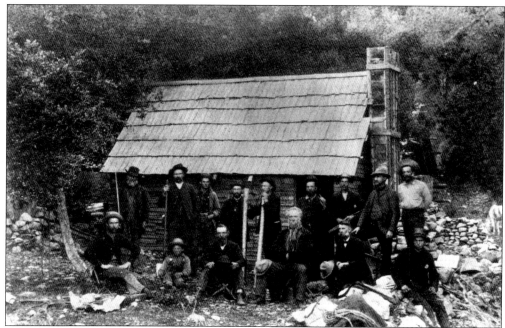

On what has been identified as the first horseback trip to Baldy, visitors enjoy accommodations at Dell's Camp above the Hog's Back in San Antonio Canyon. (Courtesy of the Cooper Regional History Museum.)

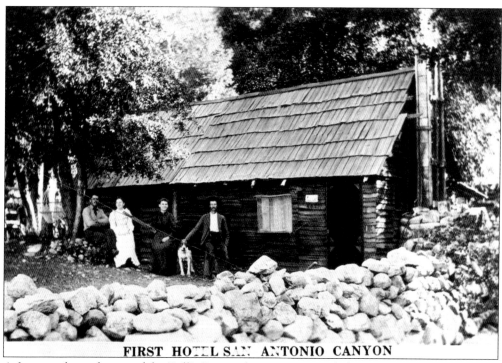

FIRST HOTEL SAN ANTONIO CANYON

A few years later, the size of the Dell's Camp cabin was increased, thus making it, as labeled, the "first hotel" of San Antonio Canyon. (Courtesy of Jane Leffler.)

24

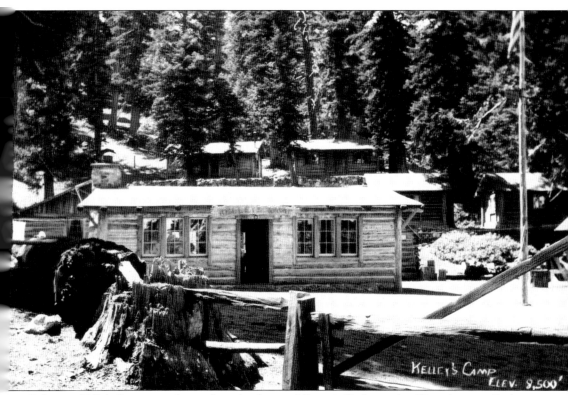

Cabins at Kelly's Camp were located on the slopes of Ontario Peak, south of San Antonio Peak. Originally named for John Kelly, who started a mine and built a single cabin there in 1905, the area later became a camp when Henry Delker applied for a resort lease in 1922. Delker added a lodge (center) and, with the help of a British man known simply as "Pop," built additional cabins. (Courtesy of John Robinson.)

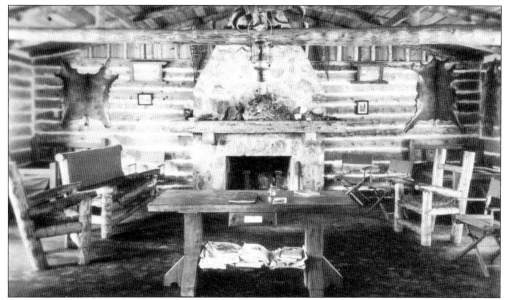

Here is an interior view of the cozy lodge at Kelly's Camp, where hikers could congregate by the fire and eat a warm meal prepared by "Pop." (Courtesy of the Chapman family.)

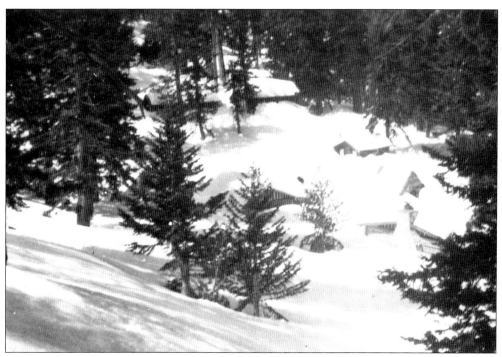

Due to the high altitude of Kelly's Camp, heavy snow was a common sight in the winter months. This scene captures the amount of snow found during a typical winter, but during January and February 1932, the snow levels reached 20 feet, leaving the cabins completely covered. (Courtesy of Ray Minnich.)

The first lookout to be built in the Angeles National Forest was located on what is still known as Lookout Mountain, south of San Antonio Peak. Built by the San Antonio Fruit Exchange, this structure was in use from 1914 until 1927, when it was destroyed by fire. A second lookout tower was later built at Sunset Peak. (Courtesy of John Robinson.)

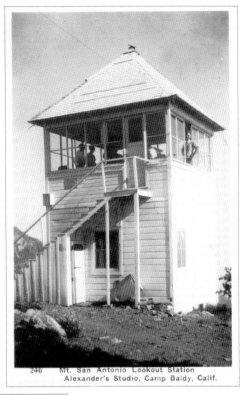

246 Mt. San Antonio Lookout Station
Alexander's Studio, Camp Baldy, Calif.

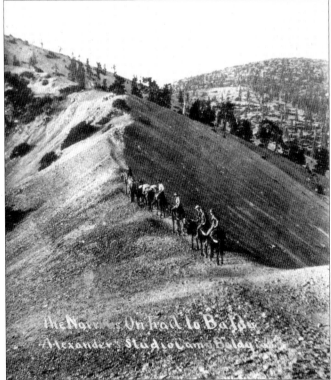

The Narrows is a ridge trail that runs up Bear Canyon, a tributary of the San Antonio Canyon, to San Antonio Peak. Access to the top of Mt. Baldy can be made either from the Devil's Backbone or from the Narrows. (Photograph by Dan Alexander; courtesy of John Robinson.)

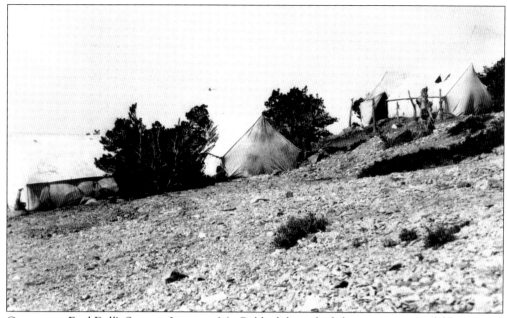

Campers at Fred Dell's Summit Inn atop Mt. Baldy did not find the amenities available at many of the other camps, such as a lodge or cabins, but instead used tents. Two storage buildings were available for provisions and equipment. The inn, open just during the summer months, only lasted three years, from 1910 to 1913, when it was destroyed by fire. (Courtesy of John Robinson.)

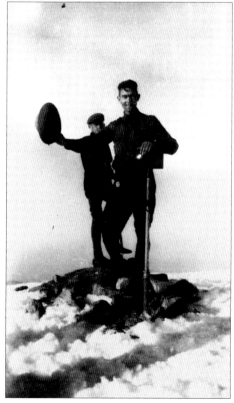

John Robinson (right), a Methodist minister and father of historian John W. Robinson, arrived at the summit after a winter hike with an unidentified companion. Snow was clearly not a deterrent for these two, who were determined to ascend the slope. (Courtesy of John Robinson.)

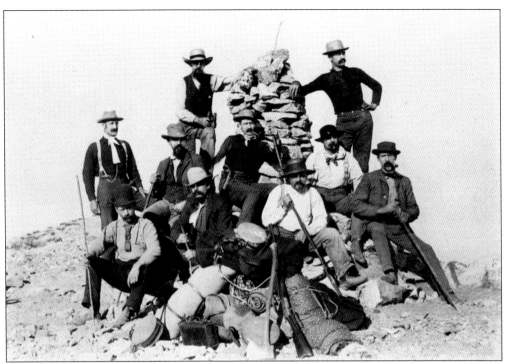

Mt. Baldy's summit was reached by many a hiker. The photograph above shows a group of hunters who, with pride, revel in their accomplishment. Decades later, a group of young men, possibly college students, enjoyed the same achievement (pictured at right). (Both, courtesy of John Robinson.)

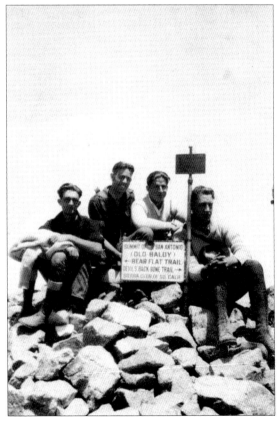

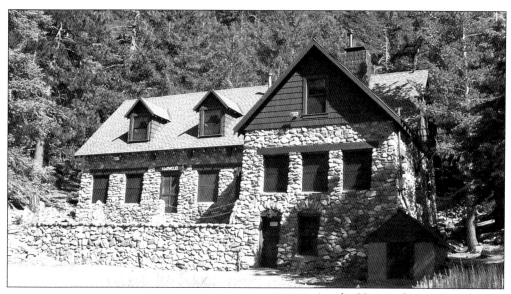

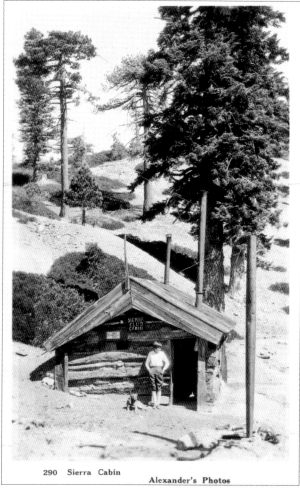

Aurelia Harwood once served as both president of the Sierra Club and leader of the Angeles Chapter of the organization. Harwood Lodge in Manker Flats was built in 1930 to honor her memory and service to the club. This beautifully maintained historic lodge continues to provide a tranquil setting in which Sierra Club members can enjoy the great outdoors. (Photograph by the author.)

290 Sierra Cabin

Alexander's Photos

The Sierra Club's cabin was located at the Notch, where the ski facilities are now located. (Courtesy of the Chapman family.)

Avid photographer, nature enthusiast, and canyon resident Dan Alexander stands outside the Sierra Club cabin in 1927. Alexander ran his photography business at Camp Baldy for nearly 30 years during its heyday. (Courtesy of John Robinson.)

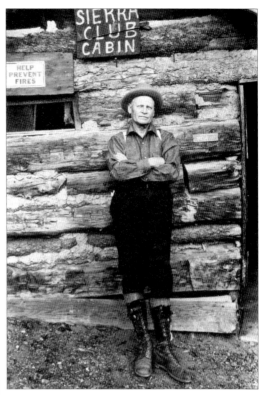

The lone cabin situated near the Notch provided hikers and skiers shelter from the elements and a place to relax. (Courtesy of John Robinson.)

This is a partial view of the first Sierra Club ski hut, built in 1936 and located on a slope of Mt. Baldy where the best skiing is to be experienced. In the days before the rope tows or ski lifts, the hut provided skiing enthusiasts shelter and a rest spot after they hiked the slope to access the ski area. (Courtesy of John Robinson.)

The Snow Crest Lodge, a favorite destination in Manker Flats, was built in 1925 by A. R. Collins and his wife. The original resort included the lodge (shown here), a small store, and a few neighboring cabins. Snow Crest remains as the last stop for lodging before arriving at the ski lifts. (Courtesy of John Robinson.)

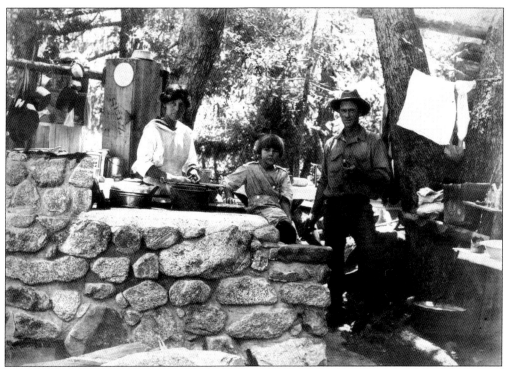

Clarence Chapman and his wife, Eleanor, came to San Antonio Canyon for their honeymoon in the early 1900s and later settled in the canyon. Here Clarence, his wife, and their daughter enjoy a meal at their camp site. (Courtesy of the Chapman family.)

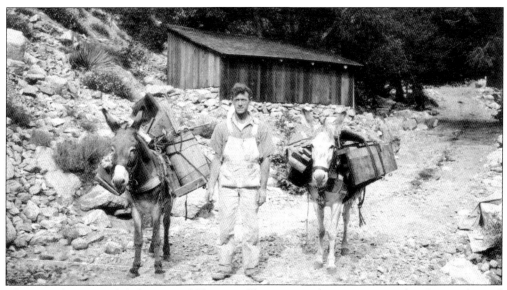

The contribution and dedication of Clarence Chapman to the canyon is evident here as he and his pack mules are about to set off on a hard day's work. (Courtesy of the Chapman family.)

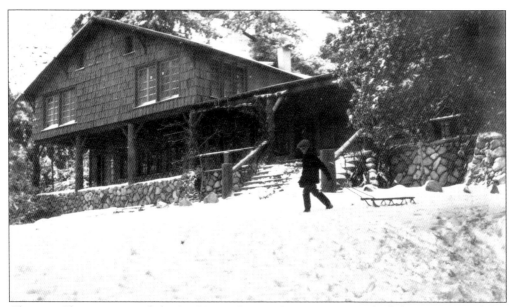

Clarence Chapman started the Ice House Canyon Resort in 1919, which he oversaw with his family for many years. (Courtesy of the Chapman family.)

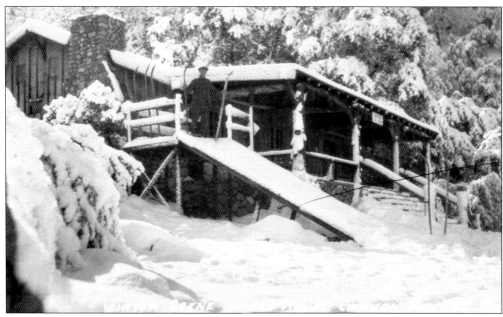

A ski ramp was added to the porch of the Ice House Canyon Resort to provide easier access in the winter months. (Courtesy of the Chapman family.)

Here is a view of Mirror Lake, a small body of water that turns into a meadow during the drier times of the year. The lake sits on a section of the privately held property that became the Chapman Ranch in 1930. (Courtesy of the Cooper Regional Museum.)

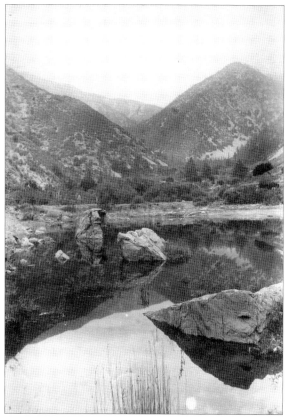

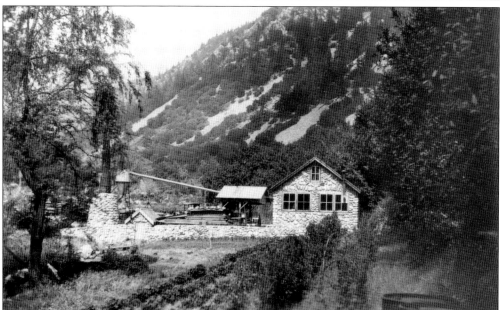

This sawmill was located on Chapman Ranch. Clarence, and later his son Robert, used the mill to provide lumber for the various structures the Chapmans built throughout the canyon. The mill stands to this day. (Courtesy of the Chapman family.)

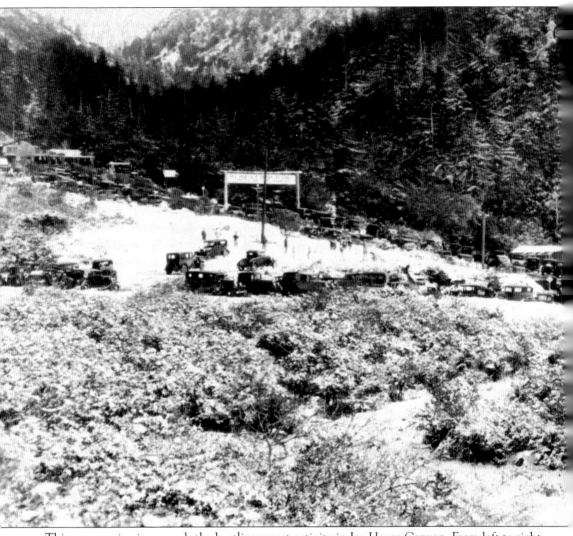

This panoramic view reveals the bustling resort activity in Ice House Canyon. From left to right are Clarence Chapman's Ice House Canyon Resort sitting proudly at the top behind the large

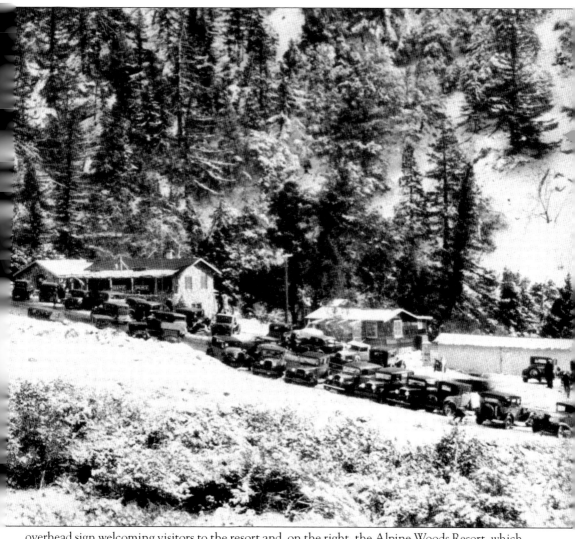

overhead sign welcoming visitors to the resort and, on the right, the Alpine Woods Resort, which was built in 1930 and was destroyed in the flood of 1938. (Courtesy of John Robinson.)

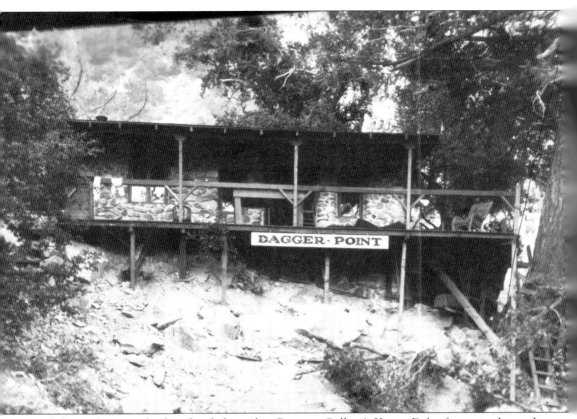

This is the second cabin that belonged to Pomona College's Kappa Delta fraternity located at Dagger Point. Built in 1914, the cabin was the popular hangout for fraternity members, whose access to the point could only be made on foot up Bear Canyon. (Courtesy of the Chapman family.)

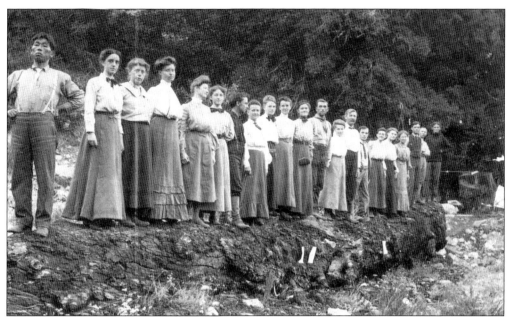

Camp Estelle, a YWCA camp located in the upper San Antonio tract, brought many visitors. These campers have lined up together upon a felled tree. The stern and determined-looking man on the far left was the camp's cook. (Courtesy of the Chapman family.)

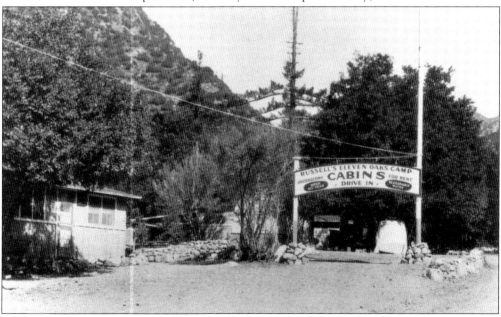

Named for the 11 oaks present at the entrance of the camp, Eleven Oaks Camp was a resort located at the base of Bear Canyon. The accommodations included a lodge, creek-side cabins, a grocery store, and a training area for boxers. During its 17 years of operation, there were several owners, including R. D. Schiffer, who started the resort in 1921. After two years of his management, the camp was sold in 1923 to George Russell, who owned the camp at the time the photograph was taken. The site of the camp is visible today near Mt. Baldy Village's fire station and post office. (Courtesy of John Robinson.)

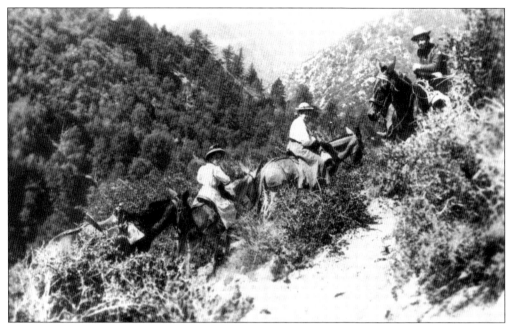

Two women and a male guide travel up Bear Canyon on mules in 1908. From Bear Canyon, a trail provides access to the summit via the Narrows. (Courtesy of the Dorothy Wisely Collection, Daven Gray.)

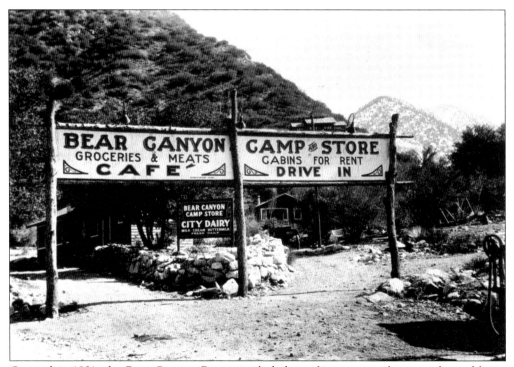

Opened in 1921, the Bear Canyon Resort included a café, a store, cabin rentals, and basic amenities for visitors. The café, seen on the left, later became the Mt. Baldy Lodge. (Courtesy of the Chapman family.)

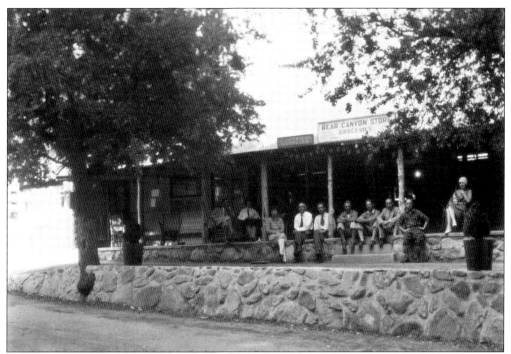

Pictured here is the store at the Bear Canyon Resort. At this time, the building greatly differed from what is now known as the Mt. Baldy Lodge. (Courtesy of the Chapman family.)

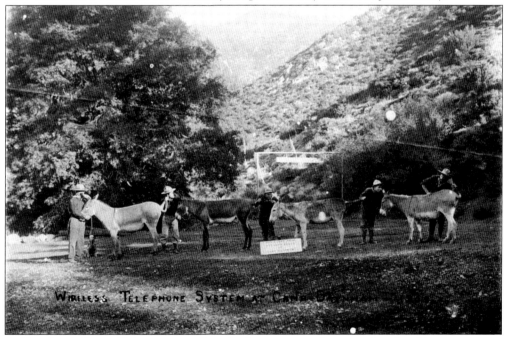

At Baynham's Camp 100 years ago, a "wireless" message was humorously relayed between scouts and mules in a fashion quite different from the methods of wireless transmission so ubiquitous today. (Courtesy of the Claremontiana Photo Archive, Special Collections, Honnold/Mudd Library of the Claremont Colleges.)

Charles Baynham, a graduate of Pomona College, established his resort in San Antonio Canyon in 1907. For approximately two years, he operated Baynham's Camp, the precursor to Camp Baldy, which was located in the "Heights" above where the Mt. Baldy Trout Ponds are now located. (Courtesy of John Robinson and Daven Gray.)

Three

CAMP BALDY

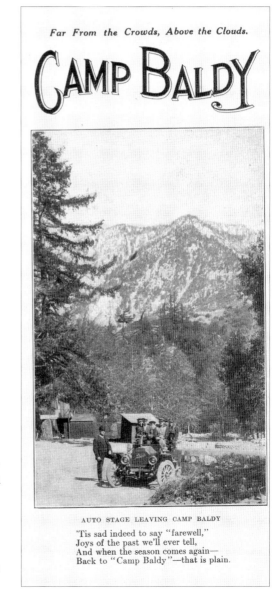

Far From the Crowds, Above the Clouds.

CAMP BALDY

AUTO STAGE LEAVING CAMP BALDY

'Tis sad indeed to say "farewell,"
Joys of the past we'll ever tell,
And when the season comes again—
Back to "Camp Baldy"—that is plain.

Camp Baldy, located at 4,700 feet, officially came into being in 1909 when businessmen from Upland purchased Baynham's Camp. Camp Baldy was for the next 30 years one of the most popular and attractive resorts in Southern California. A tourism pamphlet encourages visitors to enjoy the camp, which is "Far from the crowds, above the clouds." (Courtesy of Jane Leffler.)

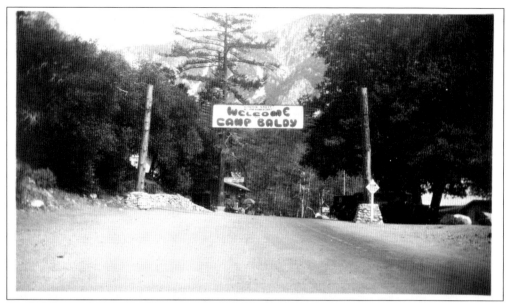

During the era of Curry's Camp Baldy, which started in 1928, hospitality was abundant, as this banner indicates. Foster and Ruth Curry worked hard to make their resort a year-round destination. (Courtesy of the Robert E. Ellingwood Model Colony History Room, Ontario City Library.)

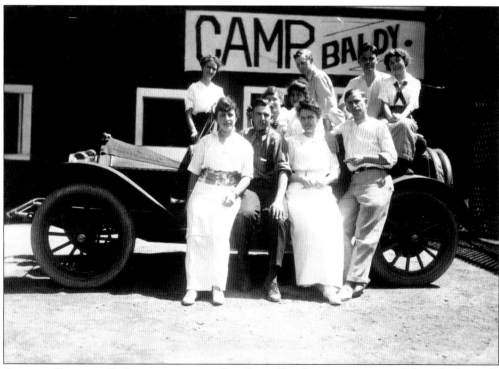

A group of happy and adventurous visitors from Long Beach sits on an automobile parked outside of the Camp Baldy office. (Courtesy of the Cooper Regional History Museum.)

The image of rows of cabins along the creek bed was a common promotional picture used during the Camp Baldy era. After the devastating flood of 1938, this serene image became a view of the past, as the numerous creek-side cabins were washed away. (Courtesy of the Chapman family.)

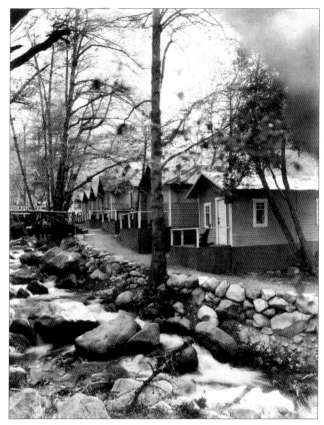

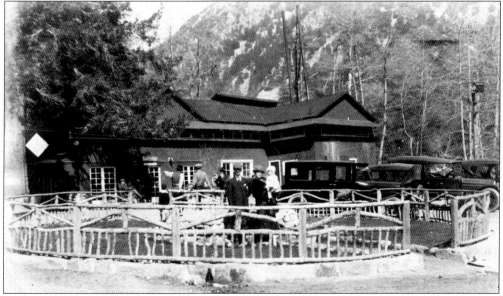

The circular drive outside the Camp Baldy office served as a welcoming area and prime location for picture taking. Various Camp Baldy services, including Alexander's Studio, barber and beauty shops, a garage, a post office, and a general store, surrounded the circle. (Courtesy of the Claremontiana Photo Archive, Special Collections, Honnold/Mudd Library of the Claremont Colleges.)

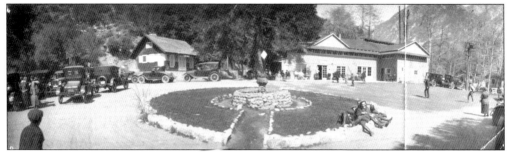

This more panoramic view of the circular drive shows the well-laid-out arrangement for easy access to services and the hotel. Ample parking easily accommodated automobiles, which had become the preferred mode of transportation throughout Southern California in the 1920s. (Courtesy of the Chapman family.)

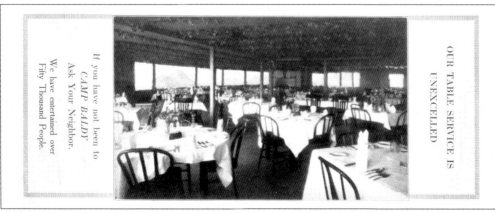

The elaborate dining room at the camp could accommodate large parties and offered quality meals for hungry travelers and outdoor adventurers. (Courtesy of Jane Leffler.)

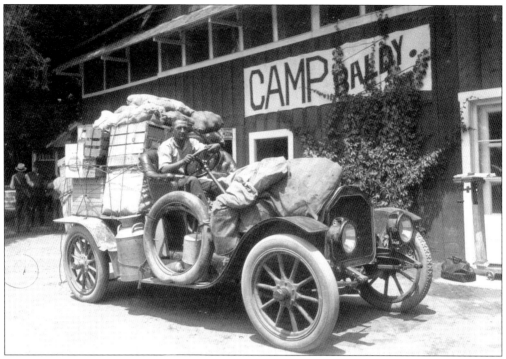

The high volume of visitors and residents required that there be daily mail service for the camp in the 1910s. (Courtesy of the Chapman family.)

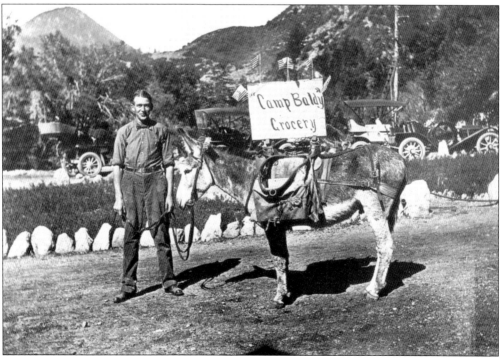

In addition to mail service, groceries were delivered from Los Angeles and Upland businesses and markets. (Courtesy of John Robinson.)

A young Robert Chapman, son of Clarence Chapman, stands in the center of the camp driveway. His invaluable contribution to the community started early in his life, as indicated by the tools. (Courtesy of the Chapman family.)

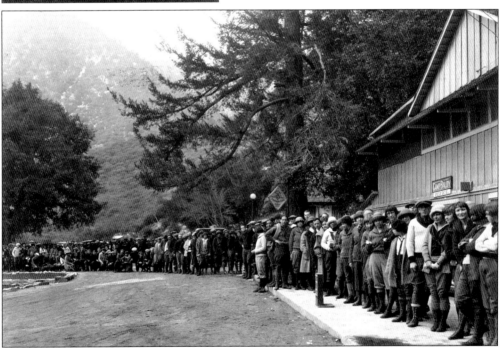

From the earliest years of the resort, students and faculty from Pomona College frequented the camp for educational and recreational purposes. The volume of students outside the Camp Baldy office is truly indicative of the camp's huge popularity. (Courtesy of the Pomona College Photo Archive, Special Collections, Honnold/Mudd Library of the Claremont Colleges.)

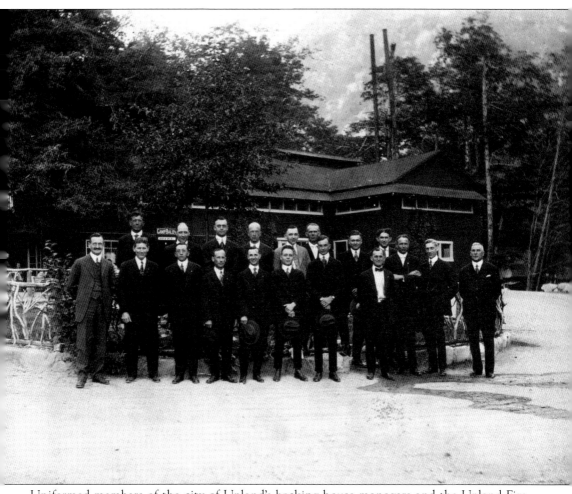

Uniformed members of the city of Upland's backing house managers and the Upland Fire Department stand together outside the Camp Baldy office. Among those pictured are (first row) F. L. Woods, Chad Francisco, Louie Kronmeyer, Fletcher Manker, Loring Kirk, Roy Monk, Dave Bradfield, and Will Beattie; (second row) Will Cline, Charles Deverts, Glenn Atwood, Kenneth Blaikie, Ernest Mehl, Aaron Brest, W. C. Fields, E. A. Rosenberger, E. W. Thayer, and Gus Hanson. In addition to serving as a firefighter on the mountain, Fletcher Manker owned a cabin in what came to be known as Manker Flats in the upper San Antonio Canyon. From his home, he supplied miners with essentials and shelter. (Courtesy of the Upland Public Library Local History Collection.)

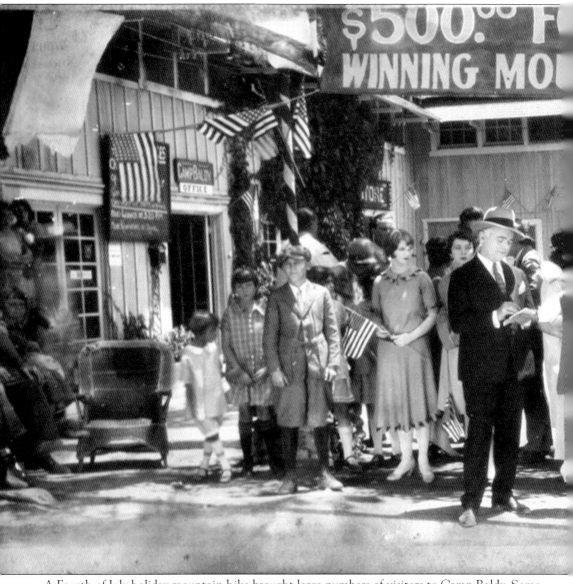

A Fourth of July holiday mountain hike brought large numbers of visitors to Camp Baldy. Some are finely dressed, and others are in costume. The visitors have gathered outside the camp's office

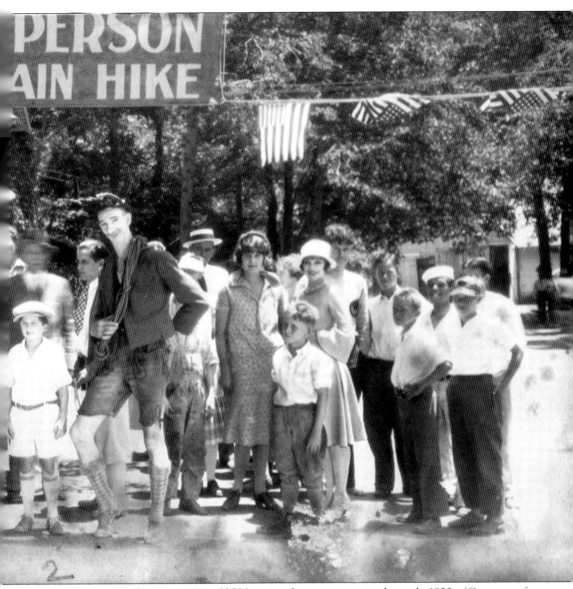

for, as the banner indicates, a prize of $500, a significant amount in the early 1920s. (Courtesy of the Dorothy Wisely Collection, Daven Gray.)

Dan Alexander's first photography studio, opened in 1906, helped promote the natural beauty and camp tourism during the nearly 30 years he lived in the canyon. His successful business was an agent for the Eastman Kodak Company. (Courtesy of the Cooper Regional History Museum.)

Alexander's Studio is seen here as it appeared around the circular drive in the camp. (Courtesy of the Cooper Regional History Museum.)

In the late 1920s, Dan Alexander expanded his photography business at the camp. His second studio, visible on the far left, gave customers more room to examine and purchase his photographs. (Courtesy of the Cooper Regional History Museum.)

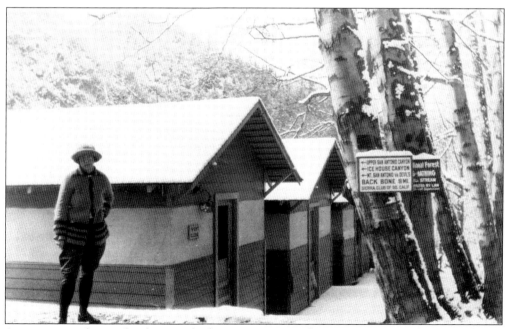

A woman stands outside of a row of cabins on a winter's day. Signage mounted on trees (right) directs visitors to various locales found throughout the canyon. (Courtesy of the Cooper Regional History Museum.)

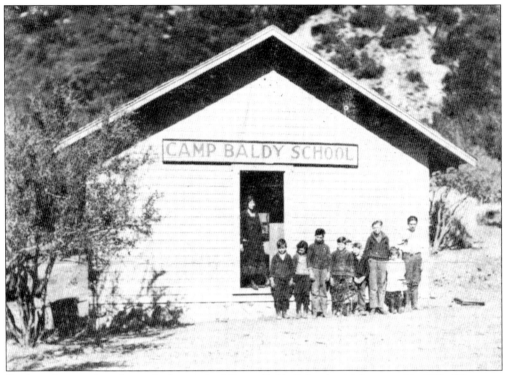

Students have gathered outside the original Camp Baldy School, which opened in 1921. (Courtesy of Jane Leffler.)

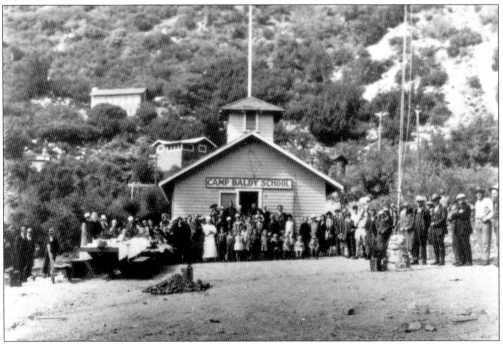

A few years later, the school was enlarged to handle an increase in the number of students and the addition of a bell tower. (Courtesy of the Chapman family.)

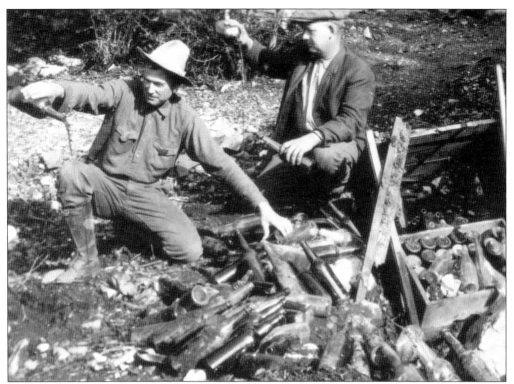

The remoteness of the camp did not deter raids by officials seeking out violators of the 18th Amendment of the United States. Between the years 1920 and 1933, when the consumption, sale, manufacture, and transportation of alcohol for consumption were prohibited, camp visitors were caught at least once with cases of illegal alcoholic beverages. (Courtesy of the Upland Public Library Local History Collection.)

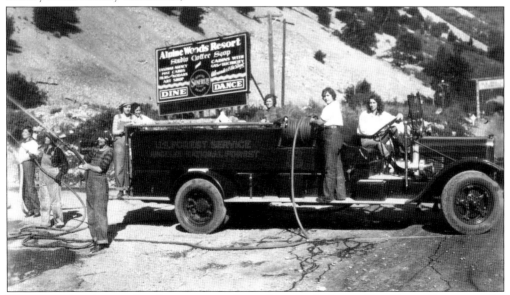

The women's volunteer fire department is shown here at the base of Ice House Canyon in the 1930s. (Courtesy of the Chapman family.)

The Camp Baldy dance pavilion was the place where visitors could enjoy the outdoors while listening to music and dancing. The site, located near the Mt. Baldy Trout Ponds, is now used for the annual Steak Fry, a fund-raising event for the Mt. Baldy Fire Department. (Courtesy of the Chapman family.)

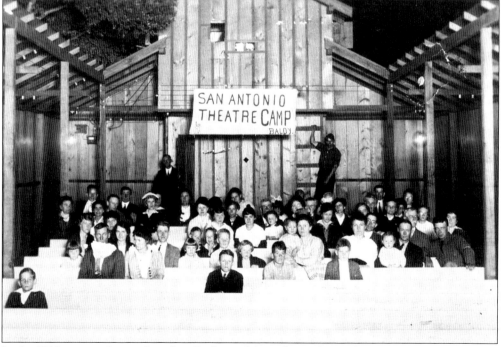

In the 1920s, movie fans gathered on Friday and Saturday nights at the San Antonio Theatre to watch feature films. (Courtesy of the Chapman family.)

Not limited to selling snacks and candy, the Camp Baldy Amusement and Refreshment Pavilion offerings included a soda fountain and lunch service, as well as amenities such as bowling alleys and pool tables. (Courtesy of the Cooper Regional History Museum.)

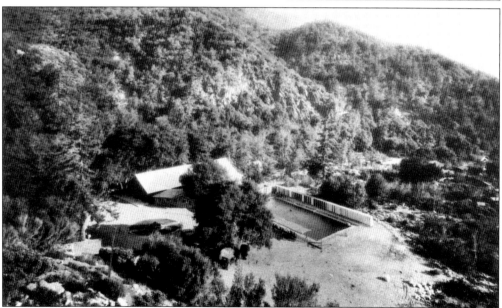

A view of Camp Baldy, as seen from above, shows the hotel hidden behind trees on the far left, while Alexander's Studio and the swimming pool, known as the "Plunge," are in the center. The refreshing water of the pool came directly from the nearby San Antonio Creek and was heated for the comfort of visitors. Sadly, the Plunge did not survive the 1938 flood. (Courtesy of the Chapman family.)

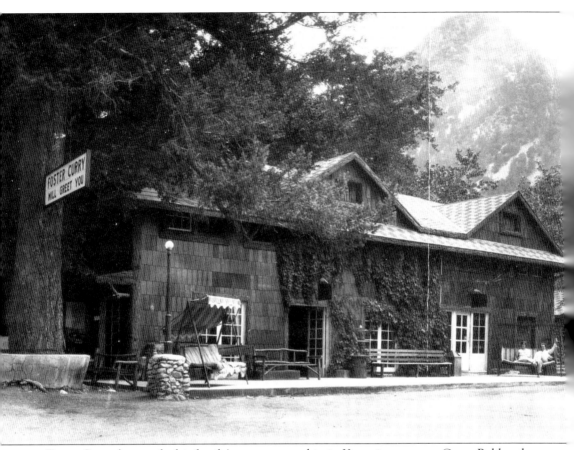

Foster Curry, known for his family's resort ownership in Yosemite, came to Camp Baldy, where he met his wife, Ruth. The former Camp Baldy office became Curry's Hotel, which lasted until 1948. The couple is seated on a bench swing on the right. (Courtesy of the Chapman family.)

Ruth (Curry) Burns stands outside of the camp hotel with her daughter. A few years later, after Foster Curry's sudden death from leukemia in 1932, Ruth married silent film actor Edmund Burns. The two continued to manage and run the business, which had done so well. A few changes occurred to the buildings, giving them a fresh and inviting new look. (Photograph by Buie Photo; courtesy of John Robinson.)

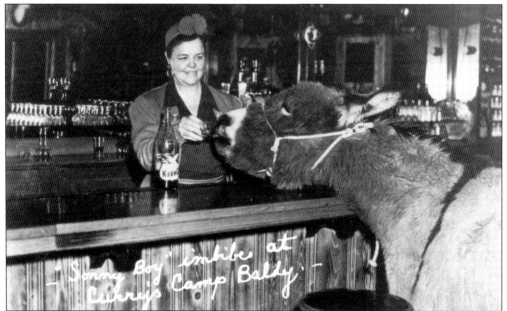

Ruth (Curry) Burns gives burro Sonny Boy a shot of Keeno at the 49ers Bar at Curry's Camp Baldy. Decades later, the 49ers Bar would become Finley's Pub, named after one of the bar's owners, Garry Finley. (Courtesy of Jon Robinson.)

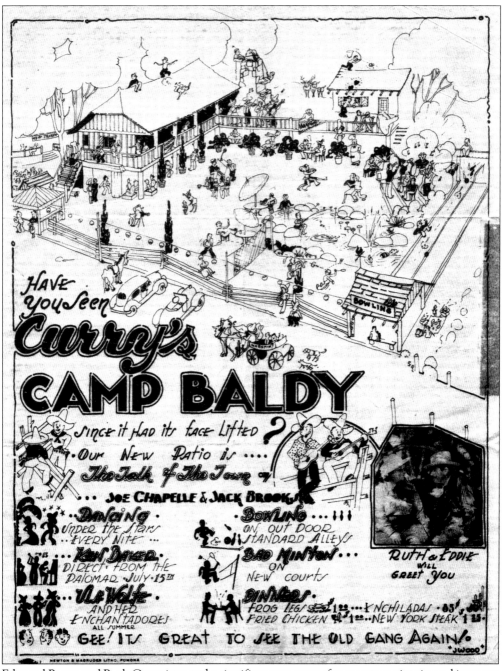

Edmund Burns and Ruth Curry invested a significant amount of money to maintain and improve the Curry's Camp Baldy facilities and to offer quality entertainment and accommodations, such as bowling, dancing, badminton, and fine dining. (Courtesy of the Chapman family.)

CURRY'S CAMP BALDY

The Yosemite of the South

Forty-five Acres of Mountain Grandeur
45 Miles from Los Angeles

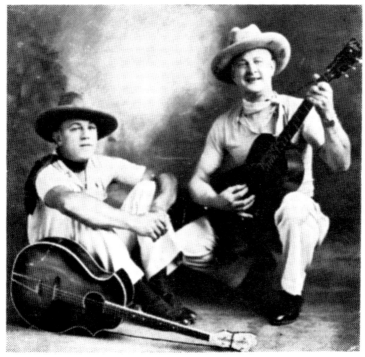

Campfire Entertainers at Curry's Camp Baldy

NEW WAGON-WHEEL CASINO AND TAVERN

California's newest and largest Dance Hall and
Dining Room, with outdoor Barbecue Patio

**CABINS BY THE STREAM — RIDING STABLES
SWIMMING POOL
STORE — POSTOFFICE — GARAGE**

RUTH CURRY & EDMUND BURNS, *Mgrs.*

Phone—Upland 1-F-4 P. O., Camp Baldy, California

The New Wagon-Wheel Casino and Tavern, located adjacent to the hotel, was built in 1937 and
lasted one year. (Courtesy of Jane Leffler.)

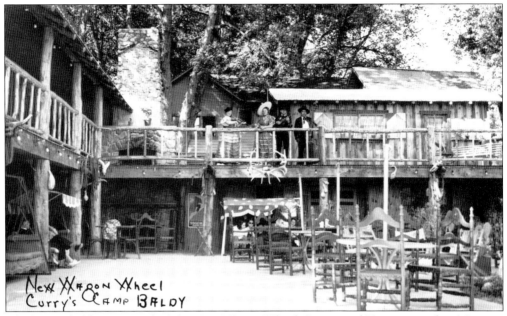

The hacienda-like courtyard of the New Wagon-Wheel Casino and Tavern reveals a Mexican influence, a popular motif in Southern California during the late 1930s. (Courtesy of the Robert E. Ellingwood Model Colony History Room, Ontario City Library.)

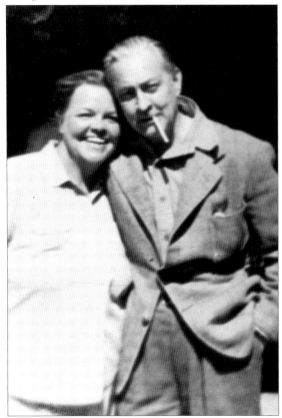

Ruth (Curry) Burns and old friend actor John Barrymore, a regular visitor to Camp Baldy in the 1930s, met in the early 1940s to reminisce about earlier times had in the canyon. (Courtesy of John Robinson.)

Four

THE FLOOD THAT CHANGED IT ALL

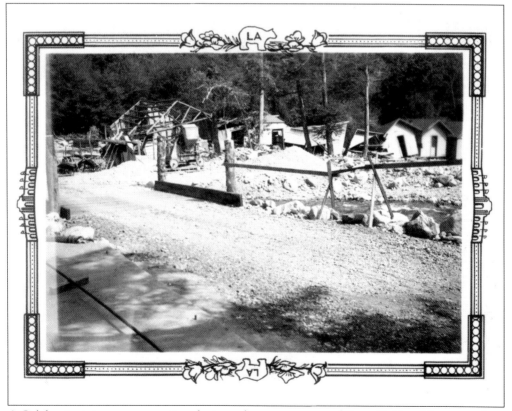

A California state commemorative photograph captures a row of Camp Baldy cabins across from San Antonio Creek near the camp's dance pavilion after the 1938 flood devastated the canyon. (Courtesy of the Dorothy Wisely Collection, Daven Gray.)

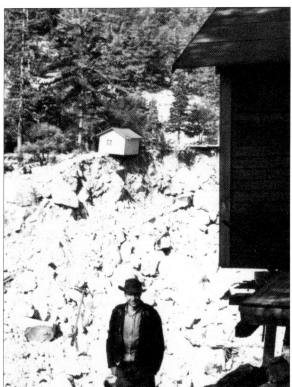

After the flood, people went around looking at the damage. This young man stands near the edge of where the floods began up in Manker Flat behind Snow Crest Lodge. (Courtesy of Ray Minnich.)

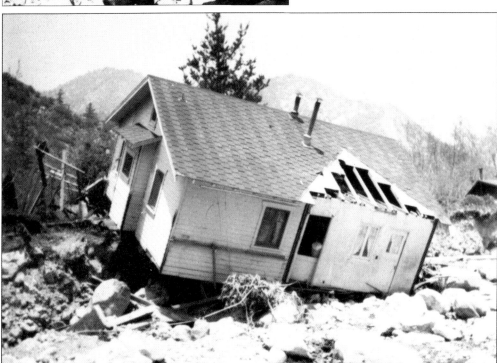

A larger cabin was forced off of its foundation and landed in the creek bed. (Courtesy of the Cooper Regional History Museum.)

Dwight (left) and Ralph Minnich stand on the debris of a cabin that was completely destroyed near Camp Baldy. (Courtesy of Ray Minnich.)

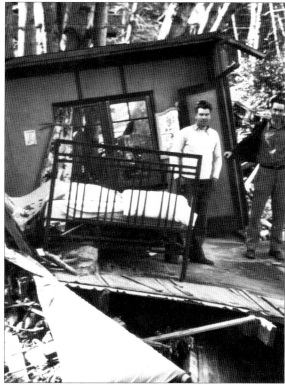

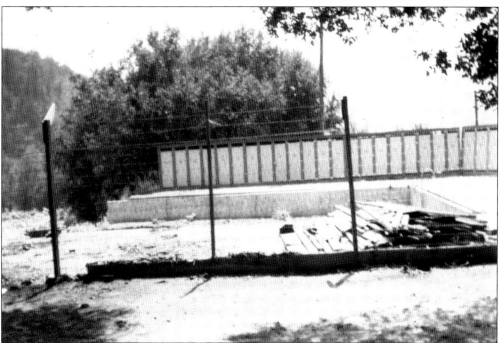

Remains of the "Plunge" at Camp Baldy can be seen next to the site of the New Wagon-Wheel Casino and Tavern. Both the casino and the pool were destroyed in the flood. (Courtesy of the Cooper Regional History Museum.)

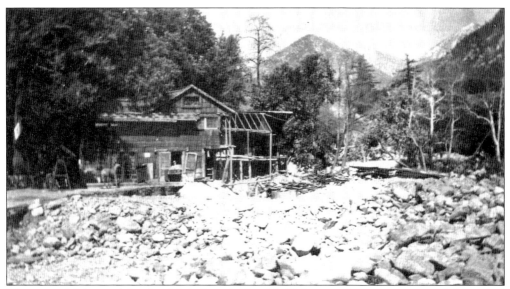

The powerful force of the flood left Curry's Hotel half destroyed as water streamed down San Antonio Creek. Looking at the flood-damaged structure from the site of the former New Wagon-Wheel Casino and Tavern, which was completely destroyed, the power of the flood is quite evident. (Courtesy of John Robinson.)

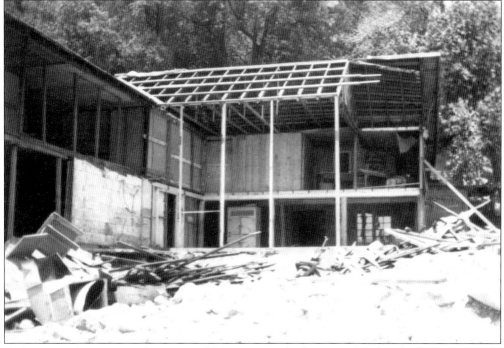

A closer view demonstrates the impact of the water upon both stories of the hotel, which surprisingly survived and was reconstructed. (Courtesy of the Cooper Regional History Museum.)

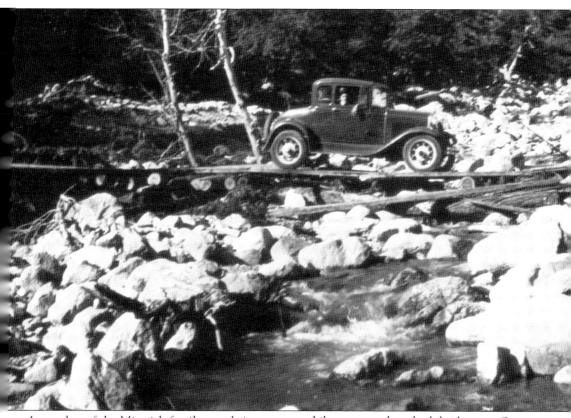

A member of the Minnich family travels in an automobile on a wooden plank bridge over San Antonio Creek in Ice House Canyon. Many large boulders and rocks ended up here as a result of the flood. (Courtesy of Ray Minnich.)

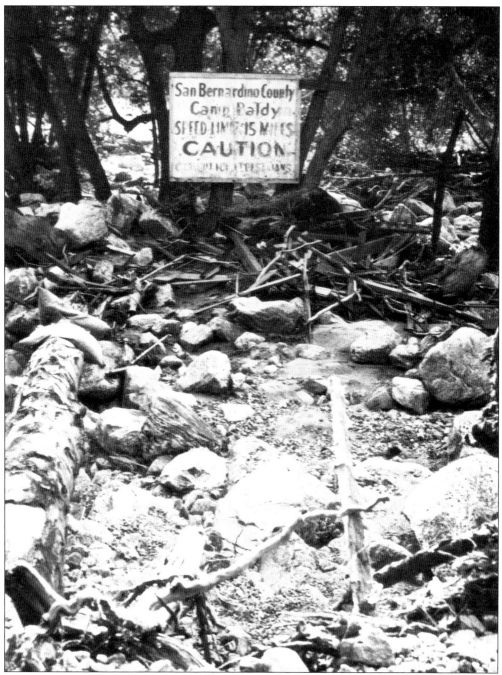

With the amount of debris and damage, it is interesting to note that the sign reads "Caution" and that the "Speed Limit is 15 Miles" per hour. (Courtesy of Ray Minnich.)

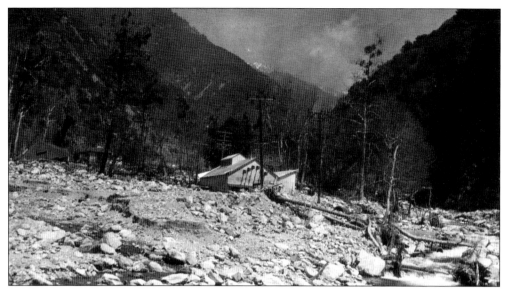

Remains of the Sierra powerhouse in lower San Antonio Canyon are strewn across the canyon floor. (Courtesy of the Chapman family.)

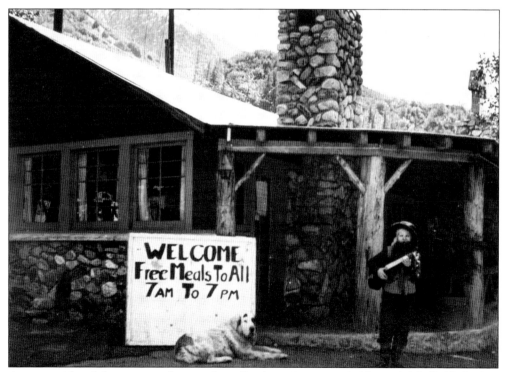

A young girl and dog promote free meals to flood survivors outside Vernon's Mt. Baldy Lodge, now known simply as Mt. Baldy Lodge. (Courtesy of John Robinson.)

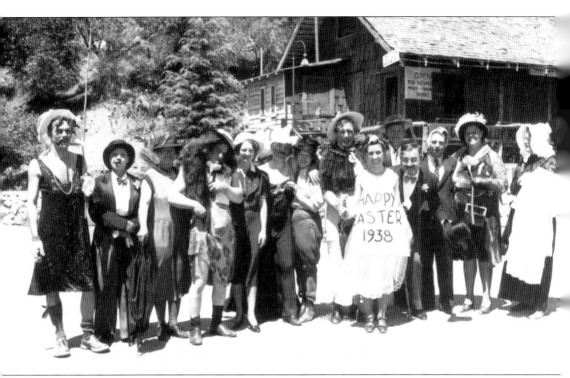

Easter in 1938 took place on April 17, more than a month after the catastrophic flood on March 1 and 2. Ruth (Curry) Burns, second from right, poses with other people, all in humorous costumes. Curry's Camp Baldy is seen in the background. (Courtesy of the Cooper Regional History Museum.)

Five

GETTING THERE IS HALF THE BATTLE

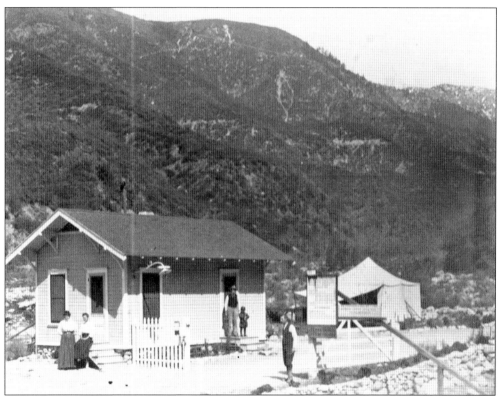

The toll road owned by the San Antonio Water Company, which was concerned with protecting its business interests and maintaining water quality, was for years how access into the canyon was made. An employee of the water company and his family lived in the tollhouse and oversaw the property. (Courtesy of the Upland Public Library Local History Collection.)

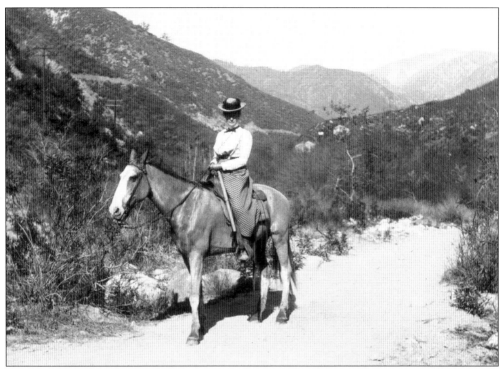

Most means of transportation used before automobiles became as reliable as they are now involved either a horse or mule. (Courtesy of the Cooper Regional History Museum.)

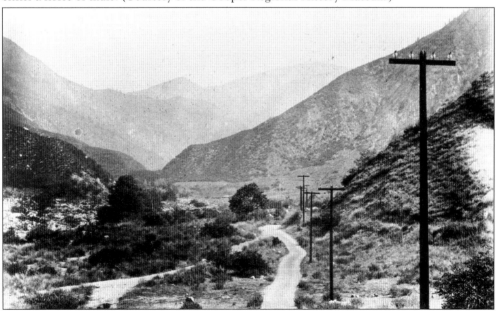

Once the Auto Road was opened in the 1920s, access up the canyon was made more easily. The Auto Road, located mostly along the canyon floor, was annually tested by floods and washouts, making it regularly unreliable. It was not until the 1950s that a higher, more sustainable road was built, making access up into the canyon consistently possible. (Courtesy of Cooper Regional History Museum.)

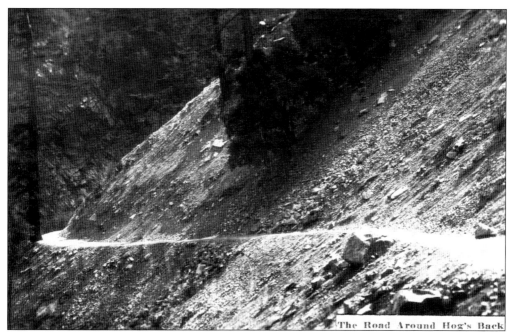

The Road Around Hog's Back

The Hog's Back, once insurmountable by automobile, became part of the single-lane road. (Courtesy of Daven Gray.)

This is the peak of the Hog's Back. The narrow road shown above curves around the bend, pictured here in the foreground. (Photograph by James Neill Northe; courtesy of the Upland Public Library Local History Collection.)

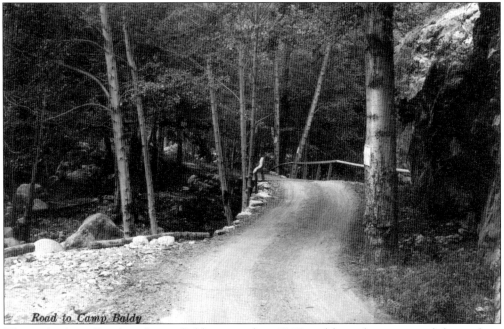

The early Auto Road to Camp Baldy opened in 1925 and brought owners of the earliest automobiles who desired to tour the scenery and experience a mountain drive. (Courtesy of John Robinson.)

Automobile tracks are seen on the Auto Road in the canyon during wintertime. (Courtesy of the Cooper Regional History Museum.)

In the early 1950s, surveyors examine plans during the construction of the Mt. Baldy Road. Temporary shacks are visible on the hillside (background) during the construction. (Courtesy of the Cooper Regional Museum.)

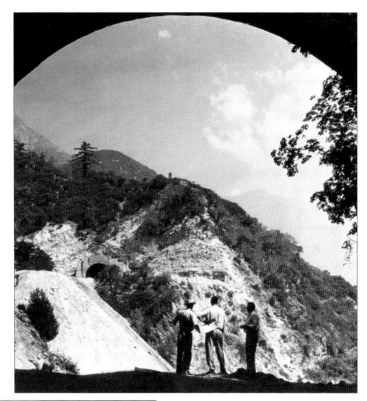

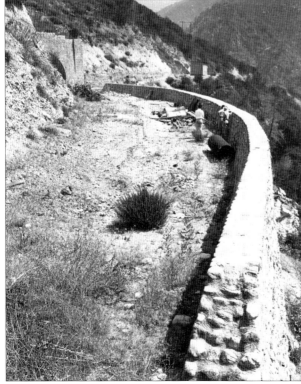

A masonry retaining wall guides the yet-to-be-completed Mt. Baldy Road to the first tunnel, completed in 1954. (Photograph by Cecil Charles; courtesy of the Herald-Examiner Collection, Los Angeles Public Library.)

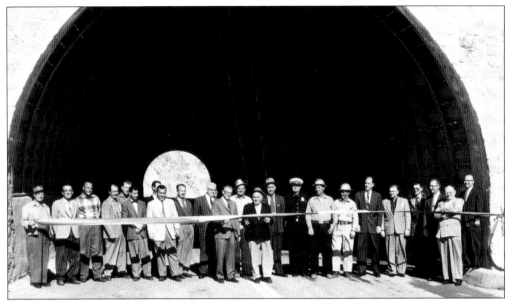

In 1955, a ribbon-cutting ceremony was held outside the second tunnel. It was an event celebrated by officials from Mt. Baldy and from Los Angeles and San Bernardino Counties, as well as representatives from the cities of Upland and Claremont. Nine years in the making, the opening of the new 12-mile, $9-million road was greeted with much excitement. (Photograph by Cecil Charles; courtesy of Jane Leffler.)

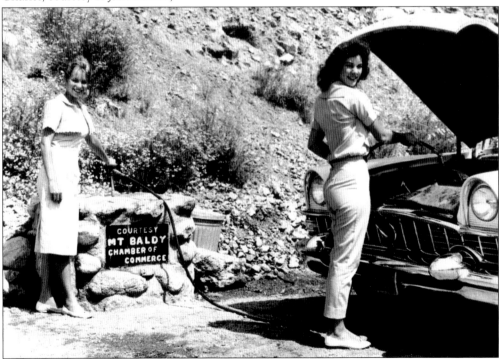

Once the new road opened, the Mt. Baldy Chamber of Commerce sponsored two roadside water service areas. Two young women demonstrate the added convenience for motorists. (Photograph by the Mt. Baldy Chamber of Commerce; courtesy of Jane Leffler.)

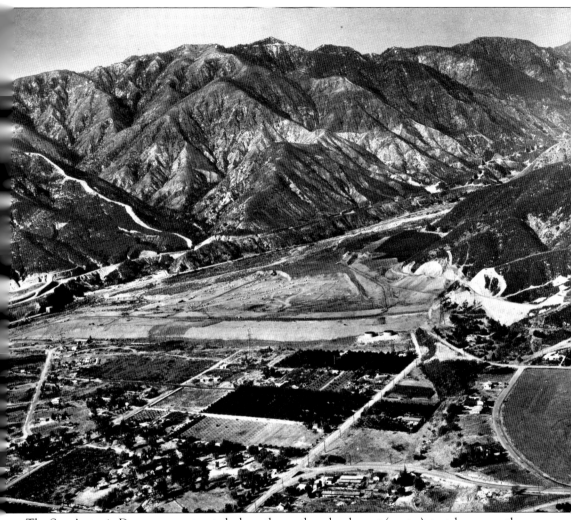

The San Antonio Dam was constructed where the earth embankment (center) stretches across the canyon floor. The multi-million-dollar project, which took four years to complete, was designed to provide 9,110 acre feet of storage for debris and floodwaters. When completed in 1956, a year after the new Mt. Baldy Road was opened, the dam included a 500-foot-long reinforced concrete conduit. (Courtesy of the Herald Examiner Collection, Los Angeles Public Library.)

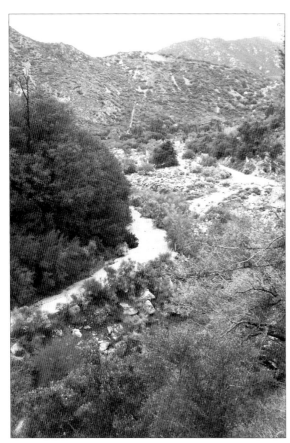

Remnants of the original road up San Antonio Canyon are still visible in many places. These views, taken from the road coming from neighboring Barrett Canyon, reveal the road's proximity to San Antonio Creek and why it suffered regular washouts during periods of heavy rain. (Photographs by the author.)

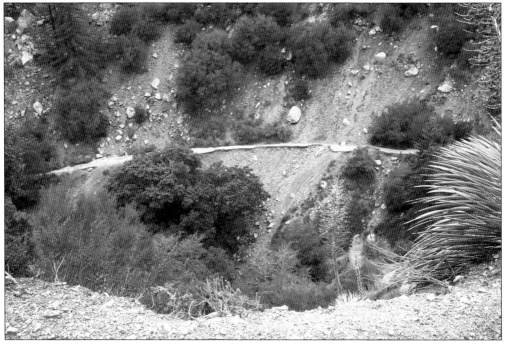

Six

SKI BALDY!

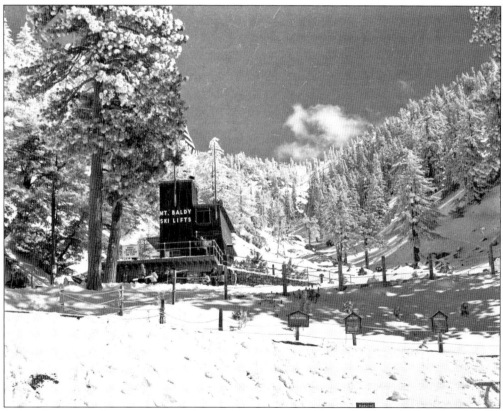

Before these new lifts were put into place in 1952, skiers were forced to hike the slopes to ski. The lifts enabled skiers to quickly access the more advanced ski areas above the Notch and to enjoy a meal at the top of the lift. A large parking lot, located just south of the lift, could accommodate the new high volume of visitors. (Photograph by Cecil Charles; courtesy of the Herald Examiner Collection, Los Angeles Public Library.)

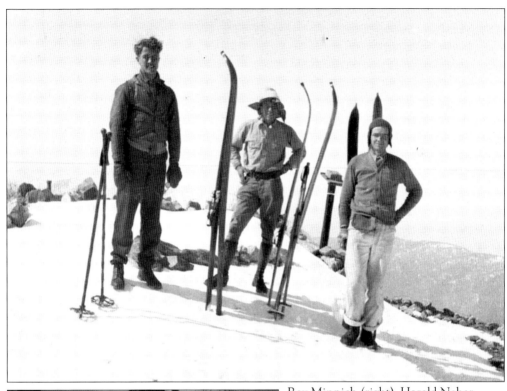

Ray Minnich (right), Harold Neher (center), and an unidentified European friend made the first ski ascent up to the Mt. Baldy summit in the early 1930s. The skis shown here came from the East Coast via Sears, Roebuck because skiing equipment was not yet readily available in Southern California retail centers at the time. (Courtesy of Ray Minnich.)

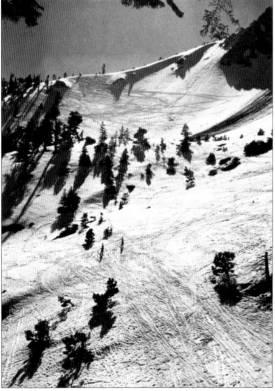

This 1937 view of the Baldy Bowl, the prime skiing area near the summit, reveals numerous tracks made by skiers who made the ascent on foot several years before any lifts were made available. (Photograph by Ethel Severson Van Degrift; courtesy of John Robinson.)

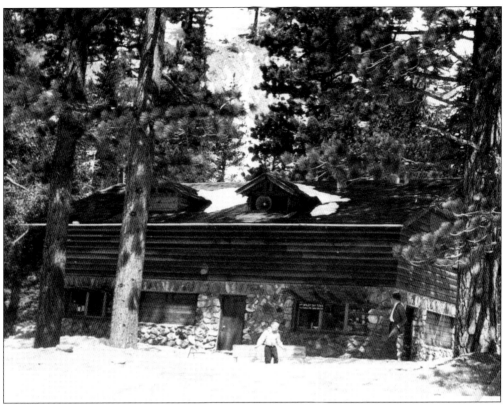

Built in 1948, the Hogan was co-owned by Herb and Jane Leffler and Snow Crest Lodge owners Hal and Leslie Ann Nelson. The right half, owned by the Lefflers, was used as a ticket counter for the nearby Movie Slope rope tow; the left half, owned by the Nelsons, included a hamburger and snack shop, and toboggan rentals. (Courtesy of Jane Leffler.)

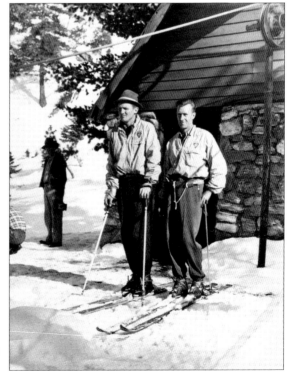

Herb Leffler (left) and Jim Chaffee stand outside of the rope tow engine house on Movie Slope, where they established the first mechanized tows on Mt. Baldy. (Courtesy of Jane Leffler.)

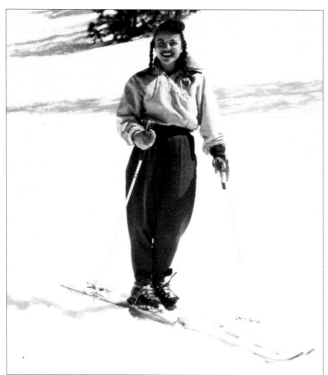

Jane Leffler, who married Herb in 1941, supported her husband's development of the skiing facilities and is an experienced skier in her own right. Jane has remained a dedicated member of the community since the late 1940s, when she and Herb first moved to Mt. Baldy. (Courtesy of Jane Leffler.)

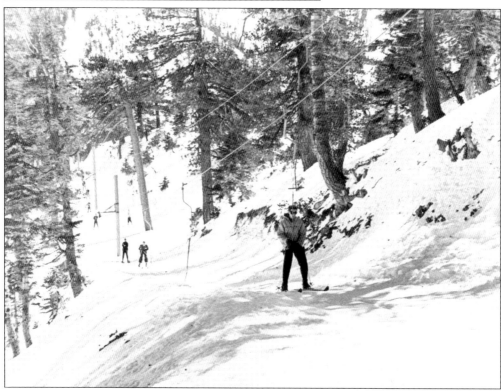

Skiers ride the platter pull near where Chair 4 was later built. (Courtesy of Jane Leffler.)

In order to fund and construct the ski lifts, a full-service restaurant for skiers, the road to the lifts, and adequate parking, investors from Los Angeles and Pasadena were brought in to form the Mt. Baldy Ski Lifts, Inc. (Courtesy of the Robert E. Ellingwood Model Colony History Room, Ontario City Library.)

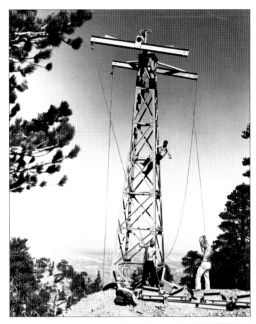

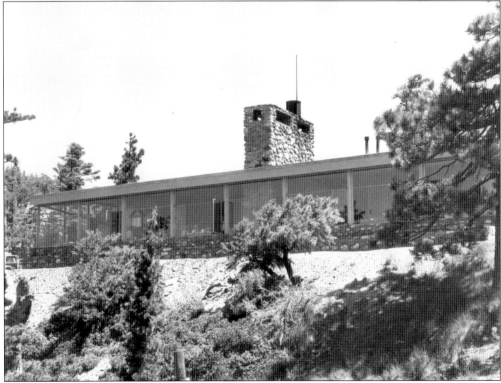

Designed by Mt. Baldy Ski Lifts, Inc., board member and famous Los Angeles–based architect William Stephenson, the first Notch restaurant served as a place where skiers could enjoy a hearty meal and the breathtaking scenic view of San Antonio Canyon as well as the communities below. In 1986, a fire consumed this beautiful structure, which was replaced by the current Notch restaurant. (Courtesy of Jane Leffler.)

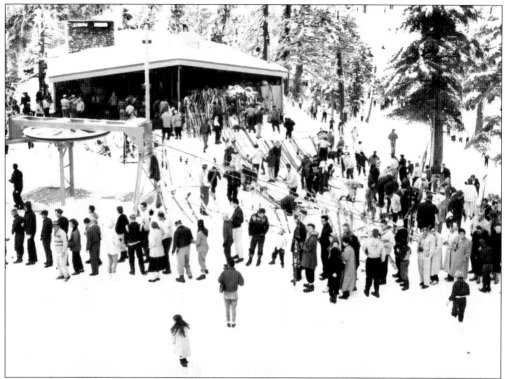

Crowds of skiers await a ride down the Sugar Pine Lift, which later came to be known as Chair 1, outside of the Notch restaurant. Mounds of skis were placed in racks on the side of the restaurant when skiers entered to dine and enjoy the view. (Courtesy of Jane Leffler.)

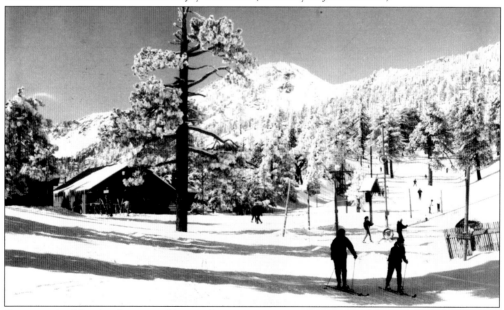

Once at the Notch, skiers could rent skiing equipment from the cabin on the left and used rope tows to access the ski runs. Over time, additional lifts were built to replace the rope tows. (Courtesy of Jane Leffler.)

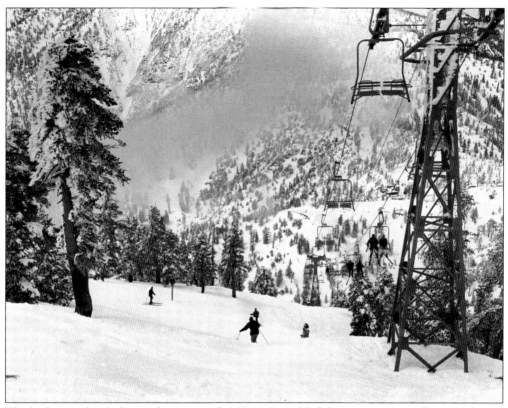

The high snow levels during the winter of 1967–1968 enabled skiers to enjoy excellent conditions and quality snow. (Courtesy of the Herald Examiner Collection, Los Angeles Public Library.)

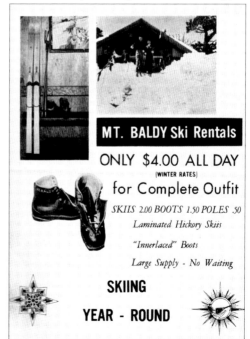

This promotional flyer guaranteed Mt. Baldy skiers could expect readily available ski equipment at affordable prices from the rental facility located not far from the Notch restaurant. (Courtesy of Jane Leffler.)

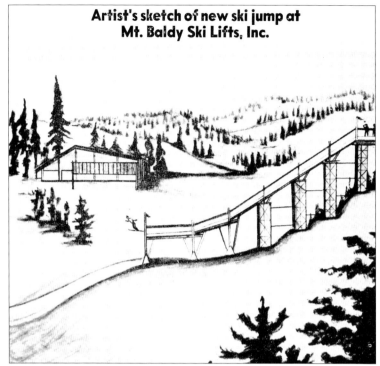

Artist's sketch of new ski jump at Mt. Baldy Ski Lifts, Inc.

A ski jump was added in 1956 to offer more adventure for skiers during both the winter and summer ski seasons. Jumping competitions were held annually. (Courtesy of Jane Leffler.)

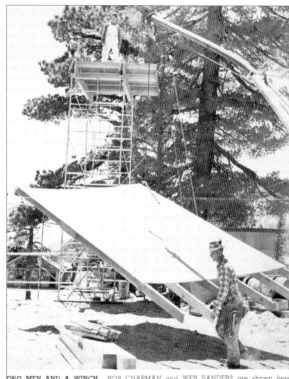

TWO MEN AND A WINCH. BOB CHAPMAN and WEB SANDERS are shown here n the process of raising the ski jump with the help of the trusty winch truck. Las year during the competitive meets, jumpers achieved jumps of 80 feet.
—CECIL CHARLES PHOTO

The ski jump was constructed by residents Robert Chapman (left, on top) and Web Sanders. (Photograph by Cecil Charles; courtesy of Jane Leffler.)

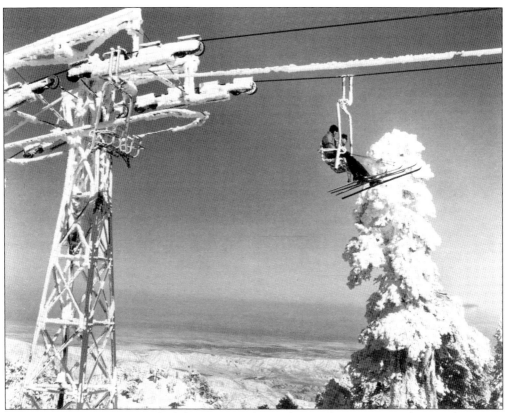

During heavy snow seasons, the lifts conveyed skiers who sought out pristine ski runs. (Courtesy of Jane Leffler.)

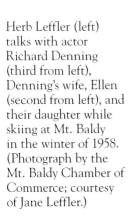

Herb Leffler (left) talks with actor Richard Denning (third from left), Denning's wife, Ellen (second from left), and their daughter while skiing at Mt. Baldy in the winter of 1958. (Photograph by the Mt. Baldy Chamber of Commerce; courtesy of Jane Leffler.)

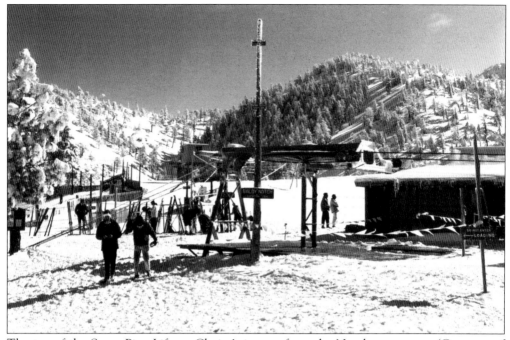

The top of the Sugar Pine Lift, or Chair 1, is seen from the Notch restaurant. (Courtesy of Jane Leffler.)

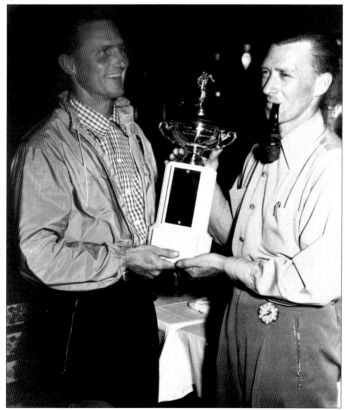

Herb Leffler (left) and Jim Chaffee hold up a trophy from a skiing contest. (Courtesy of Jane Leffler.)

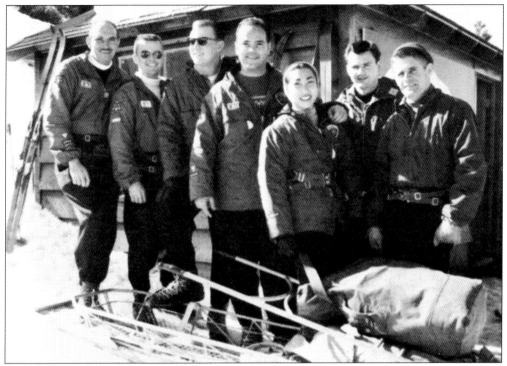

Patrol teams are used at the lifts for the safety of the skiers. Above, a team at the top of Chair 1 includes patrol leader George Mintz, assistant Jim Lewis, Al Stromerson, Bud Clark, Mary Jaffe, and Gene Frice. (Both photographs by the Mt. Baldy Chamber of Commerce; courtesy of Jane Leffler.)

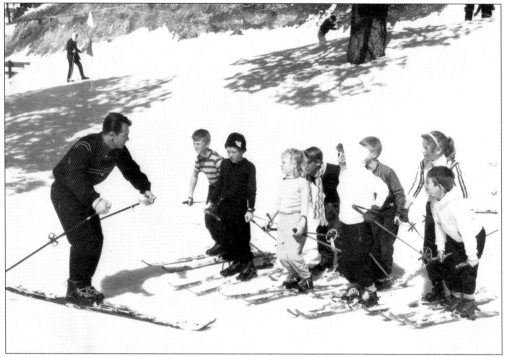

Loren James teaches a group of young students how to hold ski poles and maintain the proper posture on skis. After years as a ski instructor, James went on to become a successful Hollywood stuntman. (Courtesy of Jane Leffler.)

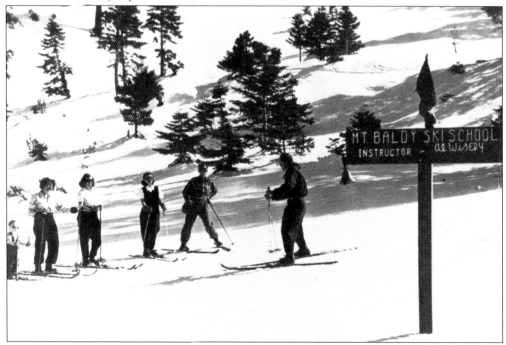

Al Wisely, a longtime resident, carpenter, and ski instructor, works with his students. Wisely was the husband of Mt. Baldy historian and teacher Dorothy Wisely. (Courtesy of Jane Leffler.)

The beautiful and iconic Jayne Mansfield poses with her skis. Mansfield was a regular Mt. Baldy visitor and skier. (Courtesy of Jane Leffler.)

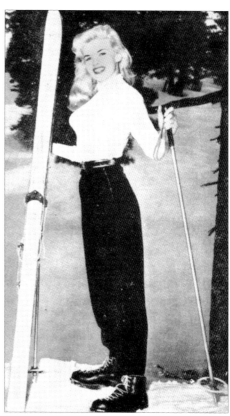

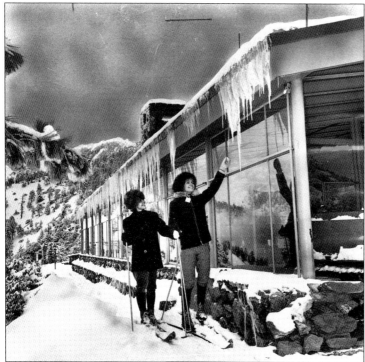

Jean Renfro (left) and Gale Solveson pull icicles from the eaves of the Notch restaurant during a ski day in December 1967. (Courtesy of the Herald Examiner Collection, Los Angeles Public Library.)

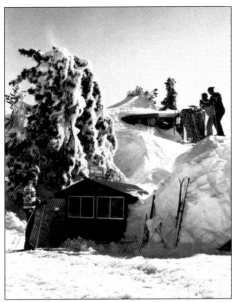

Heavy storms in 1968 brought record levels of snow to Mt. Baldy. The small Mt. Baldy Ski School hut was snowed in with several feet of snow. (Photograph by the Mt. Baldy Chamber of Commerce; courtesy of Jane Leffler.)

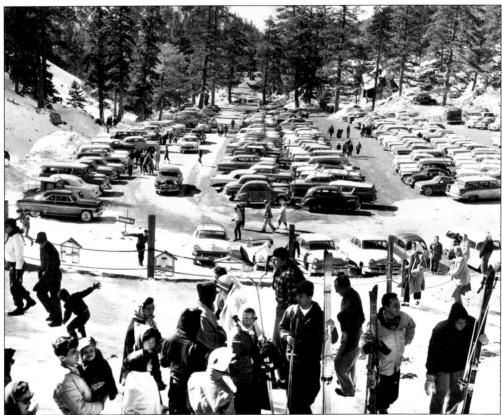

A weekend storm in March 1957 brought 10 inches of snow and the crowds to pack the ski lifts. This view captures the original parking area, which years later was redesigned to create tiered parking lots. The cabins used by Mt. Baldy Ski Lifts, Inc., pictured in the background, have long since vanished. (Courtesy of the Herald Examiner Collection, Los Angeles Public Library.)

Activities at the Notch restaurant and in the upper skiing areas were not limited to the winter months. Various summer offerings included skiing on straw, dancing, picnicking, and movies. Having a year-round calendar at the top of the lifts helped make Mt. Baldy a popular destination in the 1950s and 1960s. (Courtesy of John Jandrell.)

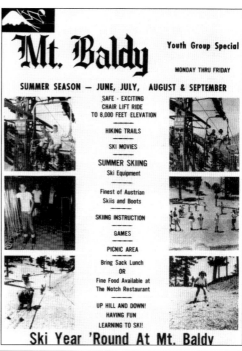

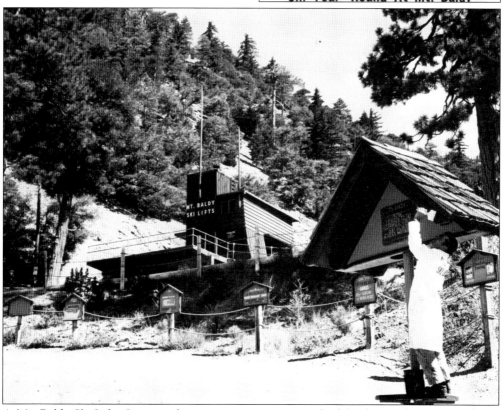

A Mt. Baldy Ski Lifts, Inc., employee paints a signpost at the lifts during the summer skiing session. (Courtesy of Jane Leffler.)

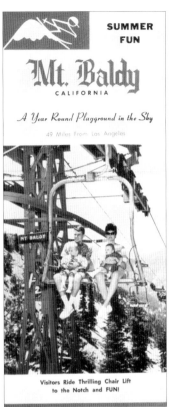

SUMMER FUN

Mt. Baldy
CALIFORNIA

A Year Round Playground in the Sky

49 Miles From Los Angeles

Visitors Ride Thrilling Chair Lift
to the Notch and FUN!

A promotional pamphlet advertises year-round family-oriented fun up at the Notch, where more than skiing was offered. (Courtesy of Jane Leffler.)

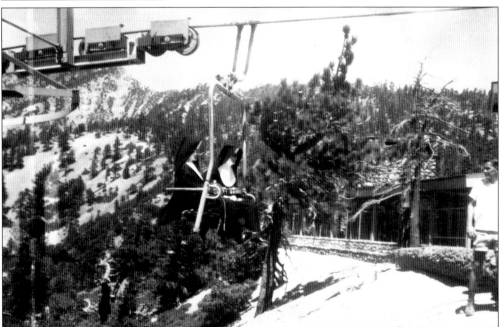

Two nuns fully dressed in habits are about to alight from the Sugar Pine Chair Lift at the Notch for a summer event. Each woman has what appears to be a pot of food on her lap. (Courtesy of the Dorothy Wisely Collection, Daven Gray.)

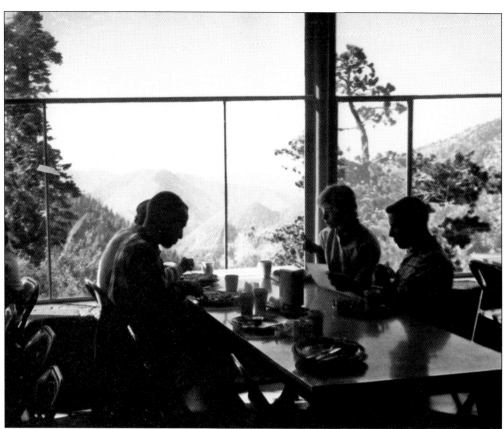

Harvey Mudd students enjoy breakfast at the first Notch restaurant, where large windows offered spectacular views of the canyon and, on clear days, the valley below. After this building burned in 1986, such open views from within the restaurant became a thing of the past. (Courtesy of the Harvey Mudd College Photo Archive, Special Collections, Honnold/Mudd Library of the Claremont Colleges.)

Mt. Baldy Ski Lifts, Inc.

MT. BALDY, CALIFORNIA

THE NOTCH

LOCATION: The "Notch" is located at a 7800 foot elevtion high atop Mt. Baldy.

EVENING ARRANGEMENTS:
 GROUP SIZE—Minimum 50 persons
 Maximum 200 persons

 LIFT RIDE—(for all affairs)—75 cents per person for round trip
 15 minutes each way
 2 persons to each double chair unit

 LODGE RENTAL (no food service)—50 cents per person

 DINNERS—Includes lodge rental
 Menu should be selected at least five days in advance
 $1.50 *SPAGHETTI*, French bread, tossed salad, beverage, dessert
 $2.50 *LAMB, PORK, HALF FRIED CHICKEN, OR ROAST BEEF*, soup, rolls, tossed salad, vegetable, beverage, dessert
 $3.25 *PRIME RIBS OF ROAST BEEF*, soup, rolls, tossed salad, vegetable, beverage, dessert
 $3.50 *FILET MIGNON OR SIRLOIN STEAK*, relish dish, soup, rolls, tossed salad, vegetable, beverage, dessert

 DANCING—Long playing record player available. Bring your own dance records. Information regarding duos or small orchestras can be obtained.

DAYTIME ARRANGEMENTS:
 Hike and play in the mountain air
 Group minimum does not apply on Saturdays, Sundays, or holidays
 Lift rides 75 cents per person round trip for groups of 20 or more

 BREAKFAST'S—Complete mountain breakfast $1.25

 PICNICS—Short orders served at reasonable prices. You are welcome to bring your own luncheons if you wish.

TELEPHONE: Contact Herb Leffler for further information—Day YUkon 32-0777; after 4:30 YUkon 32-0577.

A 1960s informational flyer details the types of services, meals, and group deals available at the Notch restaurant. (Courtesy of Jane Leffler.)

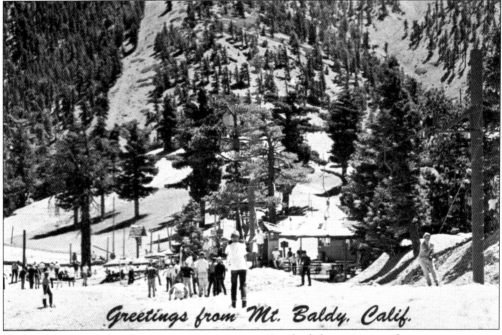

This postcard captures the summer skiing season. On the left, a woman rides a rope tow up to ski down upon straw. (Courtesy of the author's collection.)

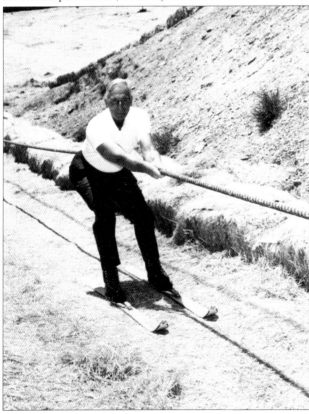

Mt. Baldy beauty pageants director George Burns uses a rope tow to ski down on straw during a summer season at the Mt. Baldy Ski Lifts, Inc. (Courtesy of Jane Leffler.)

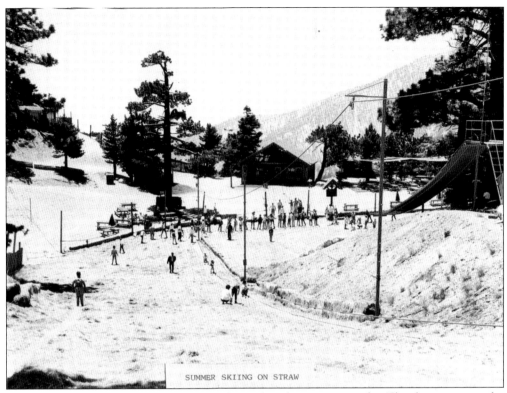

SUMMER SKIING ON STRAW

Ski jumping and other activities were not limited to the winter months. The ski jump is on the right, and the ski equipment rental cabin is in the background. Summer visitors could choose to picnic at tables (center) in the ski areas, as well. (Courtesy of Jane Leffler.)

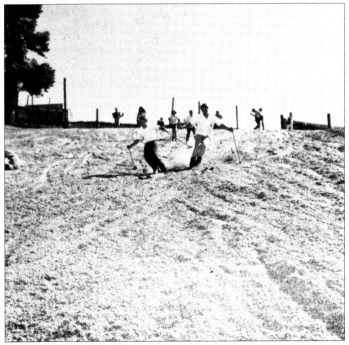

Laketow Hill was designed for more advanced skiers. Cottonseed hulls were used to provide a smooth, soft surface during the summer ski season. (Courtesy of Jane Leffler.)

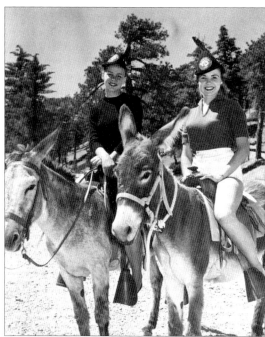

Two young women riding burros pose to promote summer fun at the Notch. Burro rides were one of the many ways to explore the Notch in the 1950s. (Photograph by Cecil Charles; courtesy of Jane Leffler.)

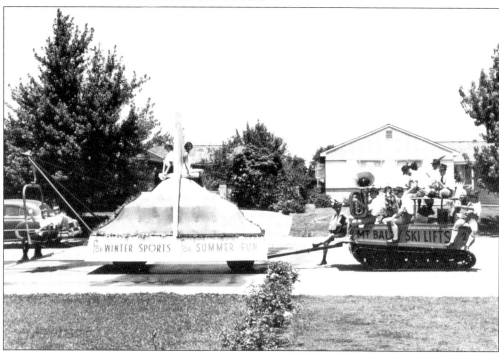

For a Fourth of July All-States parade in Ontario, a Mt. Baldy Ski Lifts, Inc., float was created. The front of the float shows two young women in a ski lift attached to a miniature mountain advertising both winter and summer fun up at the lifts. The woman on the left side of the mountain is in winter clothing, while the other woman is in summer clothing. Members of the Pol-Kats Polka band are seated on a weasel used up at the ski lifts. (Photograph by the Mt. Baldy Chamber of Commerce; courtesy of Jane Leffler.)

The sleeve of this 45-revolutions-per-minute record of polka music recorded at the Notch not only provided information about the music recorded, but also about how to reach Mt. Baldy from communities as far away as Los Angeles. (Courtesy of Jane Leffler.)

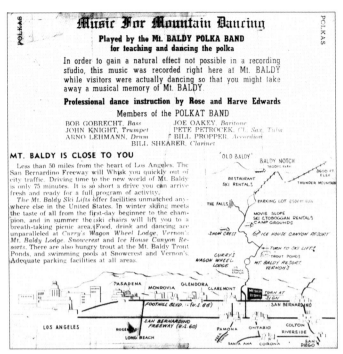

Music For Mountain Dancing
Played by the Mt. BALDY POLKA BAND
for teaching and dancing the polka

In order to gain a natural effect not possible in a recording studio, this music was recorded right here at Mt. BALDY while visitors were actually dancing so that you might take away a musical memory of Mt. BALDY.

Professional dance instruction by Rose and Harve Edwards
Members of the POLKAT BAND

BOB GOBRECHT, *Bass* JOE OAKEY, *Baritone*
JOHN KNIGHT, *Trumpet* PETE PETROCEK, *Cl. Sax. Tuba*
ARNO LEHMANN, *Drum* BILL PROPPER, *Accordion*
BILL SHEARER, *Clarinet*

MT. BALDY IS CLOSE TO YOU

Less than 50 miles from the heart of Los Angeles. The San Bernardino Freeway will Whisk you quickly out of city traffic. Driving time to the new world of Mt. Baldy is only 75 minutes. It is so short a drive you can arrive fresh and ready for a full program of activity.

The Mt. Baldy Ski Lifts offer facilities unmatched anywhere else in the United States. In winter skiing meets the taste of all from the first-day beginner to the champion, and in summer the ski chairs will lift you to a breath-taking picnic area. Food, drink and dancing are unparalleled at *Curry's Wagon Wheel Lodge, Vernon's Mt. Baldy Lodge, Snowcrest* and *Ice House Canyon Resorts.* There are also hungry trout at the Mt. Baldy Trout Ponds, and swimming pools at Snowcrest and Vernon's. Adequate parking facilities at all areas.

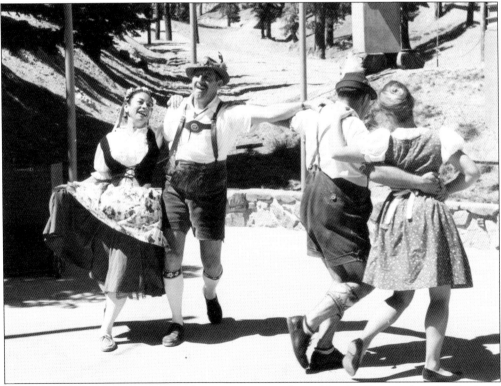

Polka dancers in full Alpine attire dance to music performed by the Pomona-based polka band the Pol-Kats at Baldy Notch. Professional polka dance instruction was offered to interested guests by Rose and Havre Edwards. (Courtesy of Jane Leffler.)

For visitors not interested in summer skiing, popular pastimes such as shuffleboard and scenic picnics were available at the Notch. (Both courtesy of Jane Leffler.)

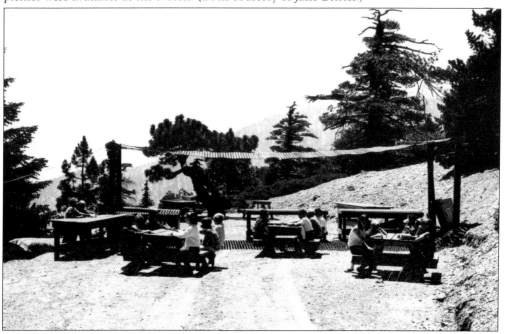

MT. BALDY'S
Second Annual Folk Festival Under The Stars
Saturday, July 24th 1965, 7 P.M. - 11 P.M.

RIDE THE SKI LIFT TO 7,800 FEET and ENJOY THESE ARTISTS

THE LEGENDAIRES
1965 Winner of "Battle of the Bands"
at Hollywood Bowl for vocal groups

THE INTERNATIONAL SINGERS
Columbia Record Recording Artists

THE NEW FOLK TRIO
Fun with Folk Music

Tickets: $2.50. Available at the Ski Lifts, Rudi-Pock, Doty's, Mac's

Entertainment options available at the Notch were not limited to the daytime hours. This flyer for the second annual Folk Festival under the Stars promotes three musicals acts who were scheduled to perform an evening concert. (Courtesy of Jane Leffler.)

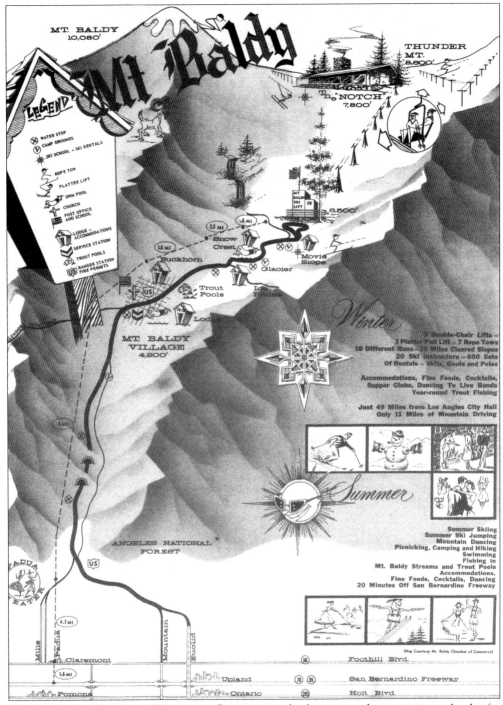

This Mt. Baldy Chamber of Commerce flyer serves as both a map and an activities calendar for year-round events held on Mt. Baldy. (Courtesy of Jane Leffler.)

Seven

REMEMBER, IT'S "MT. BALDY"

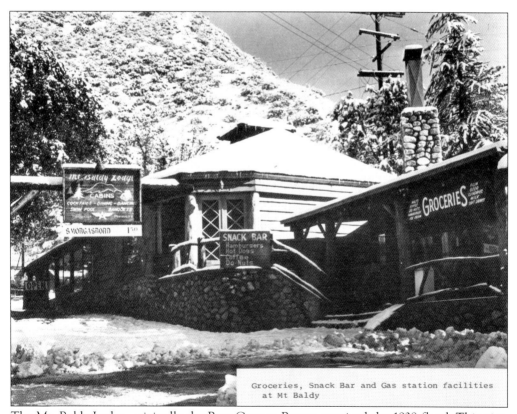

Groceries, Snack Bar and Gas station facilities at Mt Baldy

The Mt. Baldy Lodge, originally the Bear Canyon Resort, survived the 1938 flood. This view captures the lodge during the years of ownership by the Vernons. A single gas pump and small grocery store (right) are remnants of the lodge's earlier services. (Courtesy of Jane Leffler.)

Herb Leffler (left) joins radio personality Bob Crane (right), Ann Crane (second from left), and Irving and Phyllis Kluger for food and drinks at the Mt. Baldy Lodge in the spring of 1958. At this time, Crane was the premier radio personality for the Los Angeles KNXS radio station. He went on become a well-known actor on the television sitcom *Hogan's Heroes*. (Courtesy of Jane Leffler.)

Members of the Mt. Baldy bowling team, sponsored by the chamber of commerce, pose together in one of the lodges for a promotional photograph in 1958. From left to right are (first row) Vivian Thomas and Maxine Dumont; (second row) Al Dumont, Dick Putnam, and Marion Curtis. (Photograph by Cecil Charles; courtesy of Jane Leffler.)

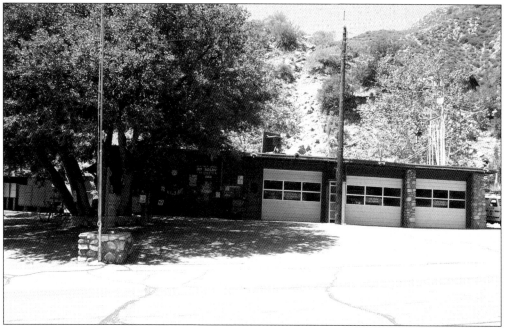

The post office (left) shares a building, constructed in 1965, with the Mt. Baldy Fire Department, founded in 1953. Before the post office was established, mail service was provided at the Mt. Baldy Lodge. (Photograph by the author.)

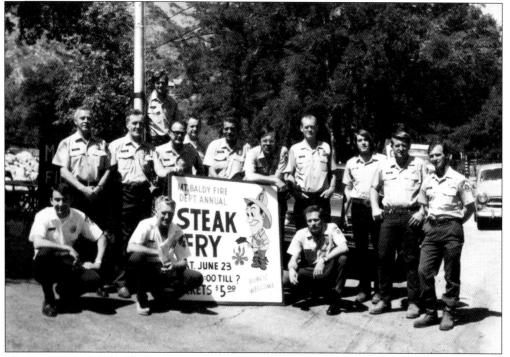

Members of the Mt. Baldy Fire Department promote the Steak Fry, an annual fund-raiser for the volunteer firefighter department, that is held at the former Camp Baldy dance pavilion near the Mt. Baldy Trout Ponds. (Courtesy of Bill Stead.)

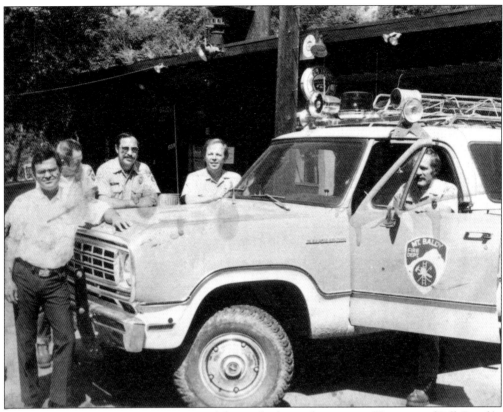

Volunteer firefighters pose next to one of their vehicles at the station. (Courtesy of Bill Stead.)

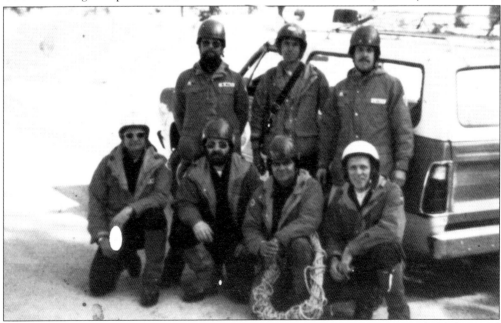

Mt. Baldy Search and Rescue provides an invaluable service when lost or stranded hikers and general emergencies arise. (Courtesy of Bill Stead.)

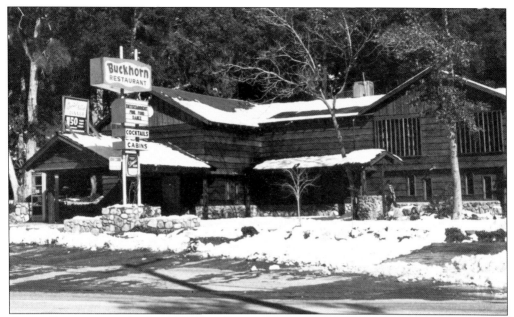

Originally serving as the Camp Baldy office, as well as the hotel for Curry's Camp Baldy, this lodge was renamed the Buckhorn after it was purchased by Democratic politician Bill Sager in 1948. Sager owned the lodge and its cabins until the mid-1990s. In 1997, Gary Finley and Chrissie Unruh, the widow of Jesse Unruh, purchased the lodge, and it continues to serve the community and visitors year-round. (Photograph by Charles Cecil; courtesy of Jane Leffler.)

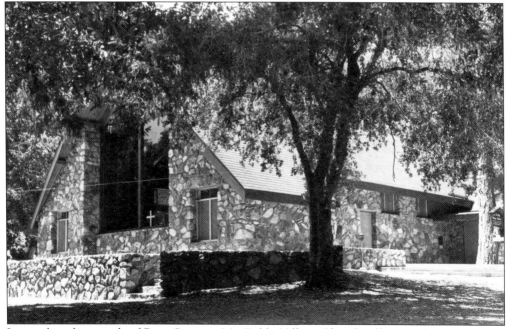

Located at the mouth of Bear Canyon, Mt. Baldy Village Church offers nondenominational services as the only church in the community. Local resident and stonemason Howard Pruitt helped construct the church, and the first service took place on December 20, 1953. (Courtesy of Jane Leffler.)

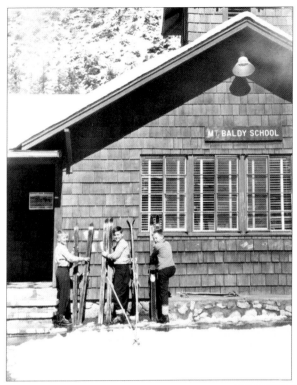

From left to right, Mt. Baldy School students Stewart Caulfield, Larry Brown, and Ricky Brown stand outside the school, ready to embark on their next skiing adventure in the winter of 1958. (Courtesy of Jane Leffler.)

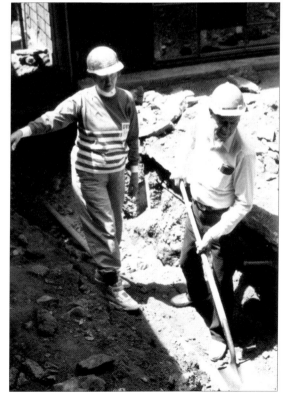

Longtime residents Paul and Dee Hansen work on the reconstruction of the former Mt. Baldy School. The two-year reconstruction project helped turn the earthquake-damaged building, which was on the verge of demolition, into the Mt. Baldy Visitor's Center. (Courtesy of Dee Hansen.)

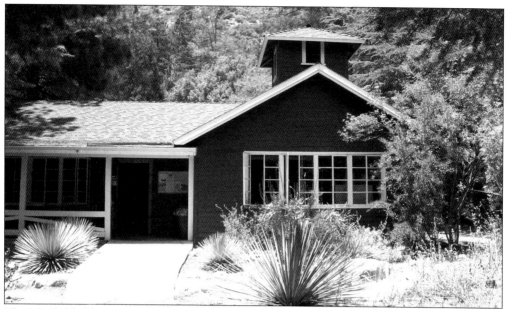

The Mt. Baldy Visitor's Center, operated by the U.S. Forest Service, offers information on local wildlife and the flora of the canyon, and recreation and historical displays highlighting the contributions of prominent locals. (Photograph by the author.)

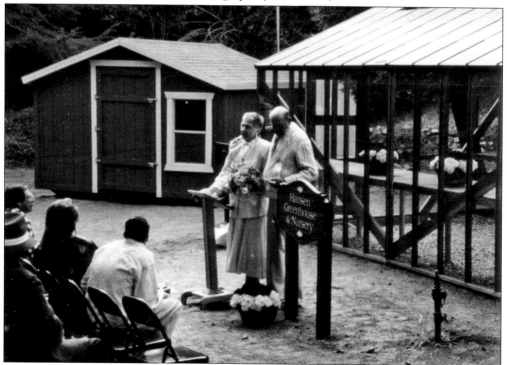

Behind the visitor's center, a trail provides access to a historical walk where exhibits present the culture of the Tongva people, the mining era, and early camp life. Another area behind the center is the Hansen Greenhouse and Nursery. Paul and Dee Hansen, for whom the facility is named, are shown here during its dedication ceremony in the mid-1990s. (Courtesy of Dee Hansen.)

The second Mt. Baldy School campus was created after the original school was damaged and deemed unsafe in the 1970s. The school, overseen by the Mt. Baldy School District, instructs students from kindergarten to eighth grade and includes a garden, an outdoor learning center, and an amphitheater to enhance the educational experience. Each day is initiated with a ring of the historic bell, which came from the school's former location. (Photograph by the author.)

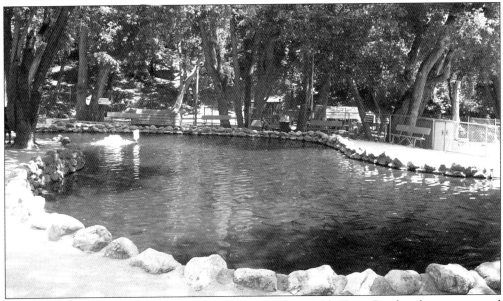

On part of the site of the former Camp Baldy are the Mt. Baldy Trout Ponds, a business started by Howard Pruitt and later purchased by the Bescoby family. The ponds continue to serve the community to this day under the ownership of another generation of the Bescoby family. (Photograph by the author.)

Eight

GLIMPSES OF THE CANYON COMMUNITIES

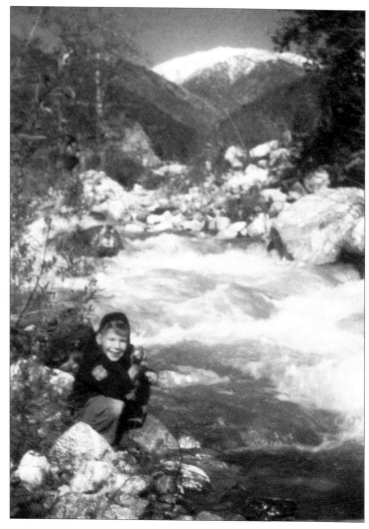

In the late 1940s, a few years before the new road was constructed, Joel Gillingwators is shown happily playing along a rushing San Antonio Creek, just east of the old road. By the looks of the creek flow, it is no wonder that the original canyon road regularly flooded. The snow-capped Mt. Baldy in the background clearly reveals the source of the water. (Courtesy of the Gillingwators family.)

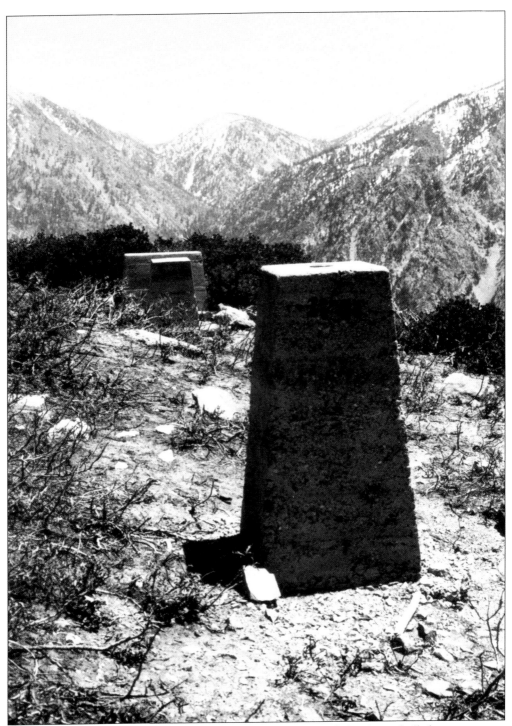

These cement column foundations are all that remain of Albert Michelson's speed of light experiments, which took place between 1922 and 1927. The experiments involved bouncing a beam of light onto a reflector located at the lookout on Mount Wilson, located farther west in the San Gabriel Mountains. (Courtesy of John Robinson.)

The Run-to-the-Top race, held annually on Labor Day, is now in its 46th year. The 8-mile course runs from the ski lifts parking lot up the peak of Mt. Baldy. The slopes are steep, and any runner willing to participate must be willing to endure the altitude as well as the rocky ground. (Both courtesy of Jane Leffler.)

The 1967 Summer Mt. Baldy News is dedicated to the field of sport activities, particularly individual endeavors, as exemplified by Larry Kunkle, winner of the 1st Annual 4-mile Long Distance Run to the Notch.

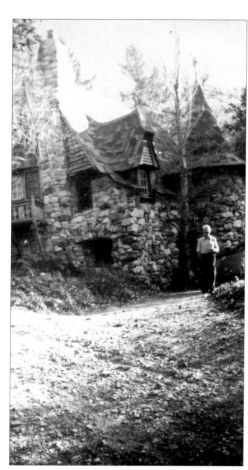

George Kayser stands outside of his Barrett Canyon retreat, the Castle. Kayser, a German immigrant, arrived in California and became a prominent Hollywood set designer. His Castle, built in 1923, had an Alpine flavor reminiscent of his native Germany. After the original Castle was destroyed by fire in 1970, a second Castle (below) was constructed by longtime resident and local historian Daven Gray in the early 1970s. (Left courtesy of Daven Gray; below photograph by author.)

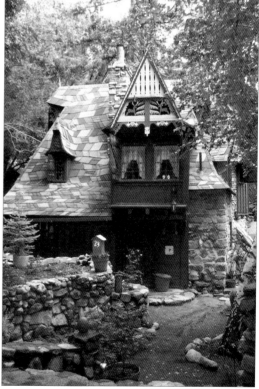

Cabin No. 32 in Manker Flats has been in the Minnich family since it was constructed in 1930 by Ray Minnich, Ralph Minnich, Archie Wolf, Agur Hawley, and Howard Neher. This view shows the cabin before an additional room was added. (Courtesy of Ray Minnich.)

Built in 1934 by Joel Gillingwaters, the grandfather of the young Joel Gillingwaters shown on page 111, Cabin No. 31 (right) was originally accessed by a road that led straight to its door. Once the neighboring ski lifts were completed in the early 1950s, this direct access to the cabin was cut off and was never replaced. (Courtesy of the Gillingwaters family.)

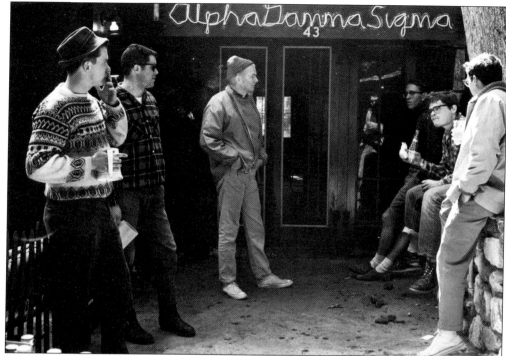

Members of the Alpha Gamma Sigma fraternity of Harvey Mudd College socialize outside their Baldy cabin. Although the exact location of the cabin is unidentified, the cabin number "43" appears above the entrance. (Courtesy of the Harvey Mudd College Photo Archive, Special Collections, Honnold/Mudd Library of the Claremont Colleges.)

A remnant of the Camp Baldy era is an oak tree in which a cement slab has been placed. The slab from the 1920s honors the original beauty and character of what was once a healthy tree. The tree is located directly next to the former Camp Baldy dance pavilion, now used to hold the annual Steak Fry fund-raiser. (Photograph by the author.)

116

Charles Chase, who founded the Folk Music Center in Claremont with his wife, Dorothy, in the late 1950s, is shown here outside the family's Bear Canyon cabin, a place he enjoyed for many years. One unique characteristic of the cabin, built in 1921, is a live tree found growing through the center of the structure. (Courtesy of the Chase-Harper family.)

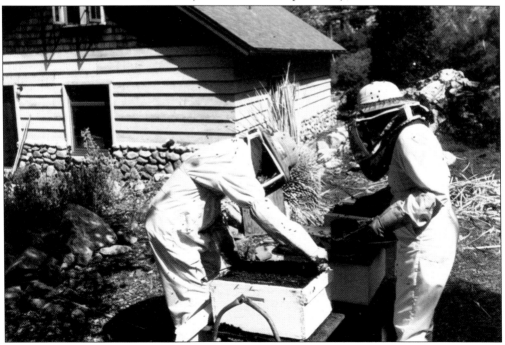

Beekeepers Paul and Dee Hansen work with bees at an apiary in preparation for a teaching session with a fellow Mt. Baldy resident. Dee sells Hansen's Honey out of her home in Ice House Canyon. (Courtesy of Dee Hansen.)

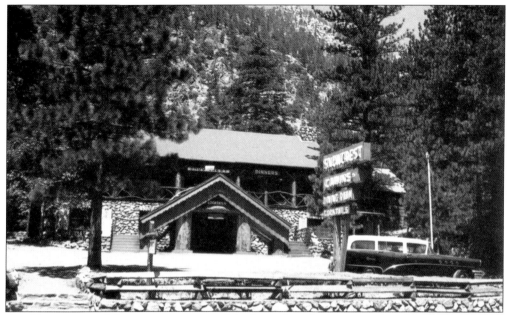

A 1950s-era postcard shows a summer view of the Snow Crest Lodge in Manker Flats during the time it was owned by Hal and Leslie Ann Nelson. The entrance to the lodge's original cocktail lounge can be seen on the lower level beneath the A-frame roof. (Courtesy of the author's collection.)

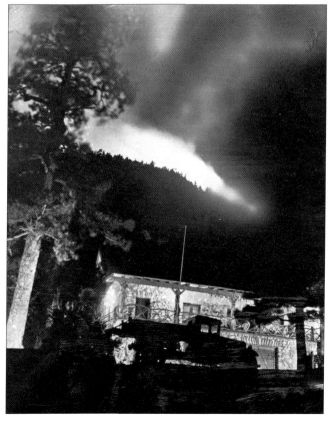

Forest fires are a regular threat to life in the canyon. The fire pictured here, which took place in late November 1948, consumed the hillside behind the Snow Crest Lodge before dawn and lit up the surrounding area with bursts of flames. (Photograph by Ben White; courtesy of the Herald Examiner Collection, Los Angeles Public Library.)

Visitors and residents enjoy the Olympic-sized swimming pool at the Snow Crest Lodge. This pool is one of two in the canyon; the other is located at the Mt. Baldy Lodge. (Courtesy of Jane Leffler.)

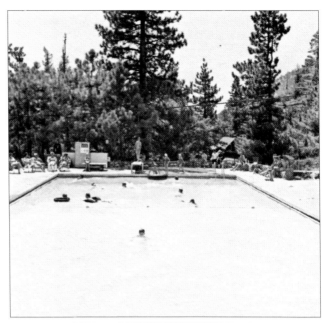

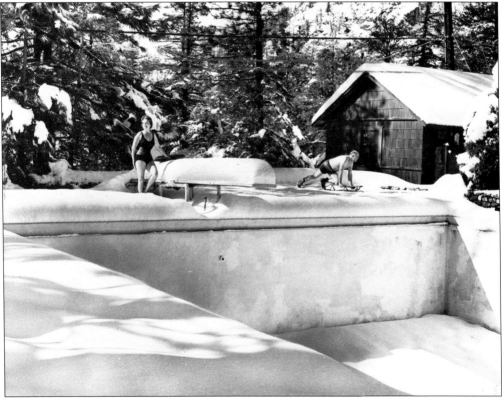

Snow Crest Lodge owners Earl and Jean Adams take advantage of the sunshine to exercise poolside after a snowstorm in January 1967. The Adamses purchased the resort from the Nelson family in the mid-1960s. Sandy Rady, current owner of the resort, is the daughter of Earl and Jean. (Courtesy of the Herald Examiner Collection, Los Angeles Public Library.)

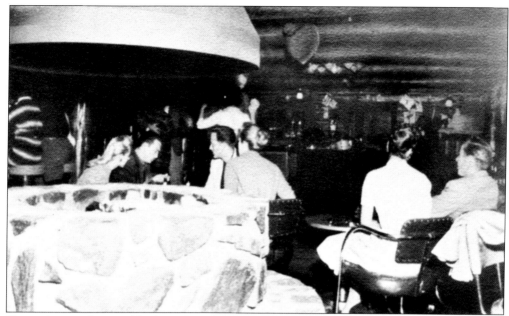

Up until it was destroyed by fire in March 1988, nearly 70 years after it was founded by Clarence Chapman, the Ice House Canyon Resort was a popular destination for those seeking fine dining, drinks, and conversation. (Photograph by the Mt. Baldy Chamber of Commerce; courtesy of John Jandrell.)

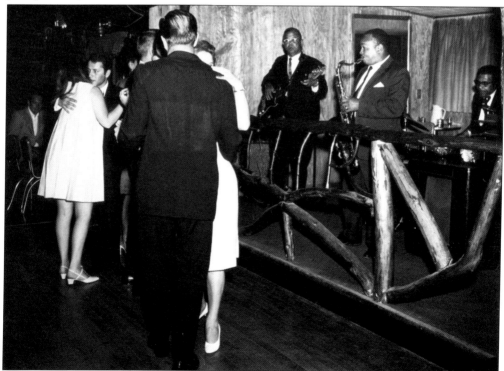

In the early 1960s, the music of Charlie Parks and his band drew steady crowds to the Ice House Canyon Resort for dancing and overall fun. (Courtesy of Jane Leffler.)

Two beauty contests became staples for Mt. Baldy; one contest was exclusively for residents, while the other was for all young women from the neighboring cities of Ontario, Pomona, Claremont, and Upland. In 1962, Judy Miller was the first beauty contestant to go on to the Miss California pageant. In honor of her accomplishment, Miller graced the June 1962 cover of the *Mt. Baldy News*. (Photograph by Cecil Charles; courtesy of Jane Leffler.)

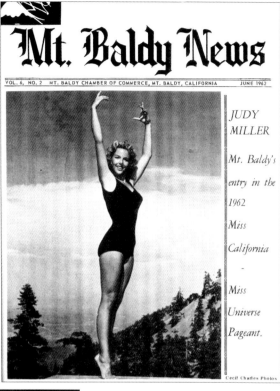

Mt. Baldy News

VOL. 6, NO. 2 MT. BALDY CHAMBER OF COMMERCE, MT. BALDY, CALIFORNIA JUNE 1962

JUDY MILLER

Mt. Baldy's entry in the 1962 Miss California - Miss Universe Pageant.

Cecil Charles Photos

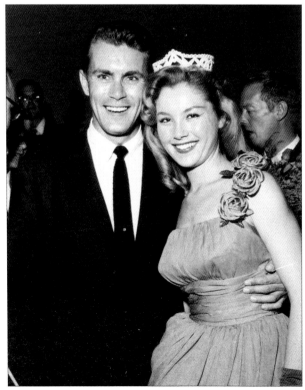

Television actor Ken Clayton celebrates with Dorene Georgeson, the Mt. Baldy Ski Club Queen, at the 1958 Annual Snow Ball. (Courtesy of Jane Leffler.)

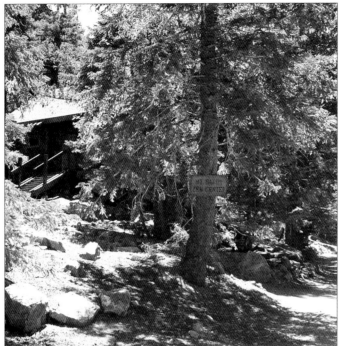

On the grounds of a former Boy Scout camp next to Harwood Lodge in Manker Flats, the Mount Baldy Zen Center provides training for students of Japanese Rinzai Zen, led by Joshu Roshi. Serving the community since 1971, the center is open for retreats and seminars. (Photograph by the author.)

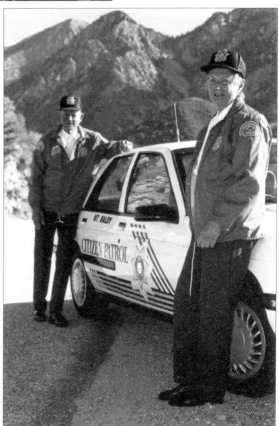

Uniformed patrollers Paul and Dee Hansen are shown on duty for the Mt. Baldy Citizen Patrol. This community service helped monitor activities and safety concerns throughout the canyon. (Courtesy of Dee Hansen.)

Nine

THE NATURAL BEAUTY OF MT. BALDY

Common among the slopes and hillsides of San Antonio Canyon is the flowering native "Our Lord's Candle," or Yucca whipplei. These hardy plants mature after about four to six years, at which point they flower and die. (Courtesy of Daven Gray.)

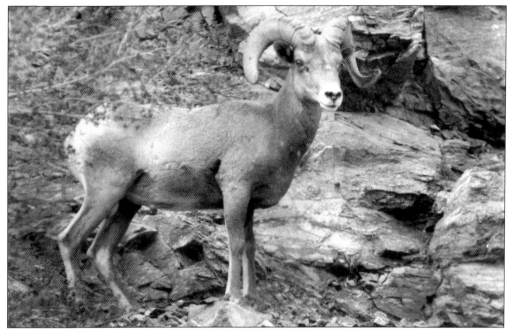

San Antonio Canyon includes a variety of wildlife, and it is a special treat to spot bighorn sheep in the higher elevations. This sheep, photographed in the 1940s near the Snow Crest Lodge, appears calm while in contact with humans. (Courtesy of Bradley Hardesty.)

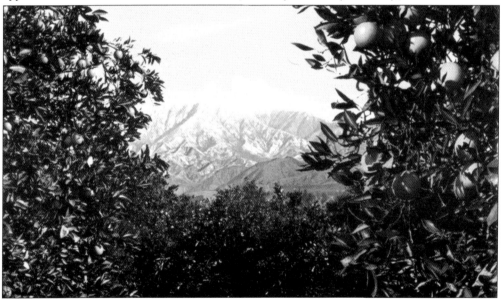

For decades, Mt. Baldy played a prominent role in tourism promotion. The "Snow & Sunshine" motif common on postcards, pamphlets, and book covers was originally developed as a means to attract tourists, business investors, real estate developers, and health seekers to this "paradise." When snow glistens on the mountain above and rays of sunshine reflect off shiny citrus leaves below, it is no wonder that this popular image of the two distinct climates in close proximity to one another helped make Southern California one of the most popular regions for tourism and residential development in the 20th century. (Courtesy of Jane Leffler.)

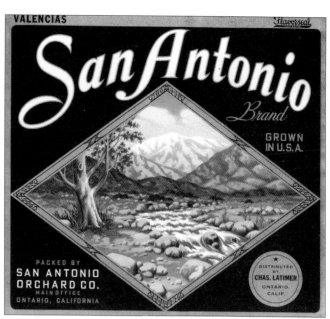

Citrus labels not only advertised the fruit packaged within the crates, they also promoted regional tourism as well. Mt. Baldy was used on labels for companies located in the Pomona Valley, one of the citrus belts in Southern California. These two examples depict the natural beauty of the canyon and peak while endorsing the supreme quality and heritage of the locally grown fruit. (Both courtesy of the author's collection.)

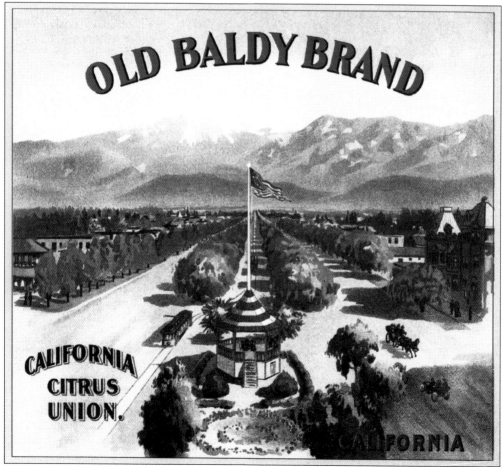

The beauty of the San Antonio Canyon and the peak of Mt. Baldy continue to inspire many urban and suburban dwellers to seek out a short-term, if not permanent, retreat from the more

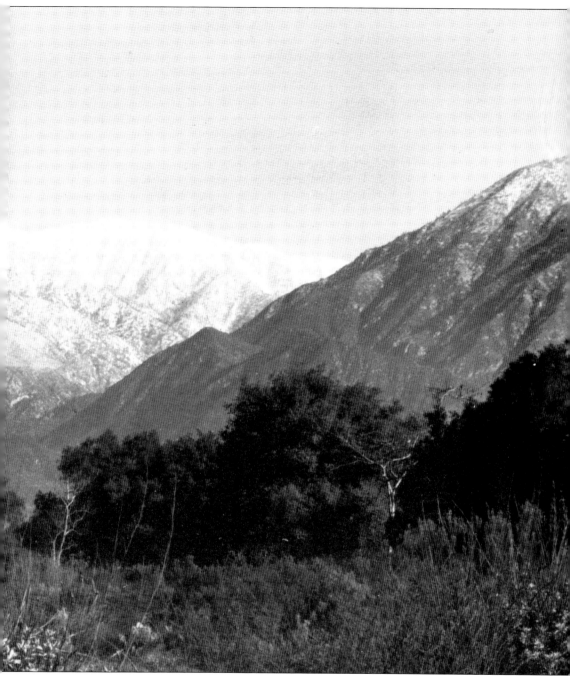

congested ares of Southern California. (Courtesy of the Claremontiana Photo Archive, Special Collections, Honnold/Mudd Library of the Claremont Colleges.)

ACROSS AMERICA, PEOPLE ARE DISCOVERING SOMETHING WONDERFUL. *THEIR HERITAGE.*

Arcadia Publishing is the leading local history publisher in the United States. With more than 4,000 titles in print and hundreds of new titles released every year, Arcadia has extensive specialized experience chronicling the history of communities and celebrating America's hidden stories, bringing to life the people, places, and events from the past. To discover the history of other communities across the nation, please visit:

www.arcadiapublishing.com

Customized search tools allow you to find regional history books about the town where you grew up, the cities where your friends and family live, the town where your parents met, or even that retirement spot you've been dreaming about.